HOCUS-POCUS

a bridge book with a difference

© 2001, Erwin Brecher

Panacea
Press

ISBN 0-9539955-0-X

Published in the United Kingdom by Panacea Press
London NW8 • fax 020 7586 8187

Printed in the UK

For my family and friends,
from Hong Kong to Manhattan.

Contents

Acknowledgements

To be fair, I suppose I have to mention Auntie Frieda of Vienna, who in the late 1920s taught me the rudiments of bridge. The only morsel of her teachings I remember vividly is a doctrine she apparently lived by, but which failed to survive the passage of time:

Der dritte Mann so hoch er kann.
(The third man as high as he can.)

The next bridge school I attended was in the Czech army. A major made up the foursome, who, pulling rank, hogged the bidding and invariably ended up in three no trump. If you knew what was good for you, you were ill advised to defeat the contract. This was often more difficult, without being too obvious, than finding a brilliant defence.

Later in London, I completed the bridge circuit, including Warwick Avenue, Dr Grosser in Hampstead, Marble Arch, The ACOL, Green Street, St. James's, TGR and finally Hall Road. All these places contributed to my collection.

More specifically, I would like to thank Squirrel Mollo for letting me use some of Victor's hands, and David Bird whose bridge column in the *Evening Standard* also provided excellent material.

Honor Flint and Freddie North permitted the use of a number of problems from the excellent *Match Your Skill Against the Masters*.

My profound thanks to all of them.

Erwin Brecher

ABOUT THE AUTHOR

Erwin Brecher was born in Budapest and studied mathematics, physics, psychology and engineering in Vienna, Czechoslovakia and London.

He joined the Czech Army in 1937, and, after the Nazi invasion of Sudetenland, he escaped to England via Switzerland.

Engaged in aircraft design during the war, he later entered the banking profession. Until his retirement in 1984 he was chief executive of financial institutions in the US, Brazil and Switzerland. In the UK he was chairman of a listed investment trust. In 1974 he became a Name in Lloyds of London.

He wrote his first manuscript in 1992, which was accepted by Pan Macmillan and published in 1994. Since then, Erwin Brecher has written a further sixteen books on puzzles and scientific subjects, which he has placed with US and European publishers. Translations of his books have appeared in Spanish, Hungarian, Dutch and Russian. In addition he has written two books in his second language—German.

In September 1995, he was awarded the Order of Merit in Gold from the City of Vienna in recognition of his literary achievements.

The IQ Booster was published in 1996 by Ebury, Random House in the UK and Sterling Publishing in the US. It expounds a novel approach to IQ testing. Since 1999 he has written three scripts for stage and screen.

Erwin Brecher is a regular contributor to magazines and radio in the UK and abroad.

Currently he devotes his time to playing bridge and chess, and to several new literary projects. In addition he acts as financial consultant to several companies.

A member of Mensa, Erwin Brecher and his wife Ellen have made their home in London, England.

Foreword

In the plethora of books on bridge, Erwin Brecher's *Hocus-Pocus* stands out like a breath of fresh air in a crowded pub just before closing time.

The unique format combines interesting and far-from-easy bridge problems with challenging and equally difficult logic puzzles.

The bridge bibliography is huge, including many brilliant books, but they have to be taken in modest doses, as complicated and often controversial bidding sequences, combined with subjective analyses, have a soporific effect on most readers.

Hocus-Pocus is different. It dispenses with bidding procedure and introduces the reader to the increasingly rare genre of the 'par problem', where only one line of play, often exotic but always elegant, will succeed. This singularity is frequently not recognised, and presents a formidable challenge, even to advanced players. What is more, many contracts are bound to fail because declarer, in the heat of the battle, does not identify the key play. This is likely to happen, although the underlying techniques are well known to the more accomplished devotees of the game.

This concept alone would make *Hocus-Pocus* a bridge book with a difference. What however makes this book a treasure is the pairing with a selection of puzzles, presenting a formidable intellectual challenge to those who find enjoyment in exercising the neurons of their grey matter.

Erwin Brecher has a winner! I liked *Hocus-Pocus* immensely. Just don't ask me how many I got wrong.

Zia Mahmood

Bridge problem

The contract is 6 Hearts. West leads ♡2. Can the contract be made?
The answer is Yes.

Take the Heart lead in dummy. Play a Spade and discard ◊A in your hand. Any return can be taken by declarer. Draw one more trump. After playing ◊K and ◊Q, draw the last trump by leading to the ♡Q. The three Diamonds in dummy will take care of your losing Clubs.

Puzzle

C is the first to identify the colour of his hat. He reasons as follows: The hat in front of me is red. If my hat were also red, then D would have known instantly that he wore blue. Therefore my hat must be blue.

Preface

With few exceptions all problems are based on double dummy exposure, with opponents passing. To derive optimum benefit from the learning process, readers should plan their play looking only at the North and South hands, before comparing with the line experts adopt in making their contracts.

Several hands appear to be extremely artificial concoctions, unlikely to occur in random distributions. This is indeed the case, but entirely in the spirit of *Hocus-Pocus*, which is designed to test your cognitive ability and powers of reasoning.

By way of light relief from the serious business of solving bridge problems as well as mind benders, each chapter contains an example of what I call 'Tongue-In-Cheek-Physics'. These include propositions which might be theoretically feasible but which are based on fallacies in the reasoning process. The astute reader will have no problem in pinpointing the flaw, while hopefully enjoying the exercise.

Erwin Brecher

Introduction

For when the one great scorer comes
To write against your name
He marks—not that you won or lost,
But how you played the game.

(Grantland Rice, 1880-1954)

Contract Bridge is a phenomenon.

It is addictive, and no game of skill has more followers. Below-average players, playing for stakes some cannot afford, come back, day after day, for more punishment.

In the western world more than 25,000 books on the game have been published. One hundred and eighty bridge magazines in twenty languages, together with 3,000 bridge columns in newspapers and other periodicals, cater for the avid devotee.

Facing such a flood of publications, could there be room for another contribution from an average player such as myself? Certainly not!

I could compile a long list of players whom I have partnered over more years than I care to count, who are much better than I, and of whom only a handful have been published on the subject. I will only mention a few who have departed into the mist of time and whose names have become part of bridge folklore.

Victor Mollo, Jeremy Flint, Dr Alan Manch, Bob Slavenburg,
Irving Rose, Ralph Swimer, Eric Leigh Howard, Joel and Louis
Tarlo, and Karl Schneider of Austria, reported to have been one
of the best bridge players of all time.

Over the years, I have contributed generously, if reluctantly, to keep them in the style, they were accustomed to.

Having admitted to mediocrity, what then is this book about? It is not about bridge in the conventional sense and is therefore subtitled *A Bridge Book with a Difference.*

My interest and expertise is in the field of mathematical and science puzzles, on which I have written and published fifteen books in five languages.

Problem-solving ability is the key to success in all walks of life. Games of skill and recreational mathematics enjoy wide popularity. Finding solutions engenders a feeling of achievement and even elation.

Pursuing the puzzle aspect, I have assembled a collection of bridge problems which differ from the traditional columns inasmuch as no bidding sequences or systems are involved. My material consists of a collection of bridge hands, many of which describe contracts which seem impossible to bring home against best defence. Yet one brilliant line, not easily recognisable, will succeed. For experts it might be shelling peas, although I wonder whether, in the heat of the battle, many would succeed. Mere mortals of the bridge arena will be confronted with a formidable intellectual challenge.

To show the similarity between bridge problems in this book and recreational logic puzzles, I have paired each with a brainteaser. Readers who can deal successfully with one, should be able to cope with the other, and in the process enjoy the exercise.

I have selected a wide range of problems to tickle the appetite of the most accomplished puzzlist. To solve them, all you need is a generous portion of common sense and some intuitional cognition, tools with which, one would assume, bridge players are well endowed.

I would draw the reader's attention to a type of puzzle which I call *Hidden Evidence*. These are in the form of narratives, describing situations which are unusual or even bizarre, and which defy any attempt to find a ready explanation. However, the puzzles are constructed in a manner, which will make the circumstances fit one, and only one, reasonable and logical

answer. This lends itself to a challenging and exciting parlour game which requires a moderator who knows the answer, and one or several contestants whose questions are only answered with 'Yes' or 'No' until the solution is found. P–48, P–55, P–81 and P–83 are typical examples

Although I do not belong to the exclusive club of bridge experts, I have, nevertheless, some philosophical contributions to make.

The Unlucky Cardholder

Theoretically, there is no such person. In mathematical terms, theoretical odds and distributions invariably materialise over a long period of time. If a Bridge-Four were dealt an infinite number of hands, then each player would, on average, hold 10 points. However infinity is a long time and in real life, bad or good runs can continue for many months.

Winning Bridge

Most experts will agree that the secret of winning consistently, is not so much in making the best of good cards, but losing the least with bad cardholding.

Over a number of sessions, good players with bad cards are known to show a profit against bad players with good cards.

Systems

From the early days of Ely Culbertson, by a process of evolution, the few systems generally used at present emerged. All of them use a mixture of natural and artificial bids. One of the most popular is basic ACOL which I favour. Many other systems have come and largely gone. The precision and super precision, Mario Franco's Marmic System, the Roman, the Blue Club, the Strong Pass, all had their days.

Fiddling around with such highly artificial systems is a put-off, an excruciating bore, and should not, and largely is not, permitted in bridge clubs.

I know about the invincible *Squadra Azzurra*, the Blue Team, which dominated the world bridge scene. What then were the ingredients to their unrivalled success for more than twenty years. The twin combination of being superb players and the stream of information provided by their system, which enabled them to identify every King, Singleton and Pointcount within narrow limits. Bidding sequences can provide more than 60 bytes of information, including doubles and redoubles, enough to describe partner's hand, down to the last important detail. But what is the point?

What makes an expert is not the volume of information available, but the use which his technique and powers of deduction can make of it. Indeed, in order to ensure a level playing field, the quantity of information, i.e. the system, should be available to all. Highly artificial systems do not meet this criterion.

I have often asked myself, why I, after more than sixty years, have not reached the higher ranks of the game. I believe I have the necessary intellectual equipment and mastery of all basic techniques. There are however other elusive elements shared by experts—flair, temperament and concentration—which, in the required mix, most players are not endowed with.

Well, I suppose you can't have everything!

The Double Dummy—Smart Ass

He or she is one of a breed of players, present in every club that I have played in. If you draw this individual as your next partner, pretend to having developed a sudden headache or an attack of diarrhoea, and leave the table.

The Smart Ass will criticise any failure to make your contract by pointing out that, with a ruffing finesse and dummy reversal, followed by a two-suit strip squeeze and a throw-in, the contract was on ice. No matter that your line of play was reasonable and perhaps superior, his condescending smile aimed at the Kibitzers implies that you haven't the foggiest.

Not quite as repugnant but belonging to the same ilk, is the…

Result Merchant

He will analyse the hands after you are one down and suggests that you should have dropped the single king of trumps to make the contract.

The difference between the two pests is marginal. The Result Merchant however is not triumphalist, but will try to convince you that his line is superior percentage play.

My Favourite Partner

On the other side of the coin, there are a few, too few, club members who are delightful partners. They might not be the best players in the club, but whenever I can, I will join their table. They are well mannered, never hog the bidding and apologise profusely if they fail to make their contract or don't find the best defence. If it happens to you, it is just: 'bad luck partner'. If you make a lay-down contract, they look at you admiringly and reward you with 'Well done partner.'

Bridge Defines Character

It reveals the best and worst traits in players. Greed, vanity, intolerance and deviousness are frequently displayed in the heat of the game.
Examples of unethical play:
• making a bid with undue emphasis.
• looking demonstrably at the score to draw partner's attention to a part score.
• hesitating in playing a card when there is nothing to think about.
• taking advantage of partner's hesitation
• playing a card with undue emphasis
• pulling a face to express disapproval of partner's lead.
At the bridge table, one has to live with these misdemeanours, as they are difficult to pin down, but I would never do business with such offenders.

Bridge Inflames Emotions

A famous case, reported worldwide, was that of Charles Bennett in 1929. He played Partie Fixe with his wife in Kansas City, USA. He went down in a contract which his wife considered a lay-down. She was heard to make an offensive remark, which the German press translated as 'Bridge Idiot'. Bennett slapped her face a couple of times, whereupon his wife fetched a gun and shot him dead. She was tried and acquitted. A perverse verdict to my mind. Acquittal of Charles, if he had shot her, following the insult in front of others, would have been justified.

Conclusion

Hocus-Pocus is a unique collection of bridge problems, constructed in a way which eliminates subjective judgement based on bidding sequences. The key to solutions lies in the application of one of a range of techniques with which most bridge players are familiar.

However, it is one thing to have heard of, and occasionally used, dummy reversals, throw-ins, the scissors coup and double ruff and discards, but quite another to recognise a situation while playing a hand.

Here, you have the advantage—with a few exceptions—of seeing all four hands. Even then, if you have solved the problems and most of the puzzles, you will have done remarkably well. If, in the process, you have enjoyed the exercise, and you are left with the feeling that your horizon has widened, Hocus-Pocus will have served its purpose.

Erwin Brecher

1. Sleight of Hand

The ultimate weapon

D. Stone, in a letter to *Geotimes* (1969), describes a geo-physical weapon which, if used by a nation with a large population, could have a devastating effect on an enemy.

Suppose, for instance, the residents of China, who now number over one billion, were to all jump in unison on pogo sticks. Such an action could set up shock waves which would amplify with each jump, reaching perhaps a magnitude of 5 on the Richter scale. This could, for example, destroy parts of the United States. To protect itself, the USA might organise jumps timed to cancel the offensive waves. But considering the difference in populations, the Americans would either need to jump from a greater height or call on the NATO allies for jump assistance.

After seriously considering all possibilities, and acting on the advice of their defence experts, history would suggest that the Pentagon would decide in favour of countering the threat in a manner other than by pogo stick. However, would this Chinese super-weapon work?

The ultimate weapon. Solution

It would not work, even theoretically. In the first instance the major devastation would occur in the country resorting to such a weapon although, according to David Stone's theory, there would be damage in the USA provided the jumps were timed in regular intervals to amplify the resulting ground waves. Stone estimates, however, that a jump would have to take place about *once every hour* for some considerable time. So, apart from the devastation at home, the attacking country's economy would certainly suffer irreparable damage.

Theoretically at least, the USA might indeed consider inviting all NATO members to organise counter-jumps, carefully timed, to cancel the ground waves initiated by their adversary, as an alternative to using advanced weaponry in defence of their shores and avoid the possibility of starting a world conflagration. Before they do so, however, let us now do a simple calculation to work out how much energy would be produced by each attacking jump, and the extent of the danger to the USA.

Assumptions	Number of Chinese	= one billion
	Average mass of 1 person	= 50 kg
	Pogoing height	= 0.5 metres
	Acceleration due to gravity	= 10 ms^{-2}
Calculation	Energy produced	= $1,000,000,000 \times 50 \times 10 \times 0.5$
		= 2.5×10^{11} joules of energy

This would produce a local earthquake of about 5.3 on the Richter scale, causing trees to sway and some damage locally. Put another way, this is about one four-hundredth the amount of energy released by the atomic bomb over Hiroshima.

The theory goes that the waves of energy from the jump would spread around the world and focus on a point directly opposite. However, the Earth would rapidly dissipate the energy, converting it into heat. We know this because, when an earthquake occurs at one point in the Earth, it does not cause damage at its antipodes. So the USA and NATO can stand down their anti-pogo defences.

B–1.

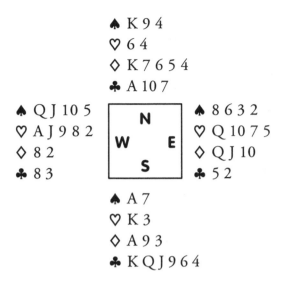

The contract is 5 Clubs. West leads ♠Q.

Winning with ♠A, declarer took two rounds of trumps and led a low Diamond from dummy, intending to insert the ◇9, so as to keep East out of the lead. East, However, couldn't be kept out, and a Heart through the closed hand spelt declarer's doom.

Is there a better line?

P–1. Special sphere

If a light metal sphere 20 feet in diameter enclosed a vacuum and weighed 300 lb., what amazing property would it possess?

B–1. Solution

```
              ♠ K 9 4
              ♡ 6 4
              ◇ K 7 6 5 4
              ♣ A 10 7

♠ Q J 10 5                    ♠ 8 6 3 2
♡ A J 9 8 2       N           ♡ Q 10 7 5
◇ 8 2          W     E        ◇ Q J 10
♣ 8 3             S           ♣ 5 2

              ♠ A 7
              ♡ K 3
              ◇ A 9 3
              ♣ K Q J 9 6 4
```

All you had to do was to let West hold the first trick. You win the next one, another Spade, maybe, and after drawing trumps, you throw a Diamond on dummy's ♠K. Now the ◇A, the ◇K and a Diamond ruff will set up two long Diamonds for Heart discards, and all is well. In fact, unless West cashes his ♡A at trick two, you should come to twelve tricks—instead of ten.

P–1. Solution

Since a 20-foot-diameter sphere of 300 lb. would weigh less than an equal volume of air (about 330 lb. at sea level and 32°F, given pressure of 0.081 lb. per cubic foot with air density at 14.7 lb. per square inch), the sphere would rise into the air. It would level off at several thousand feet and could remain there for years, riding the winds, unless of course the metal shell is not strong enough to withstand the air pressure, and collapses.

B–2.

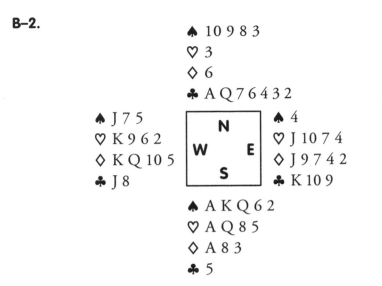

♠ 10 9 8 3
♡ 3
◊ 6
♣ A Q 7 6 4 3 2

♠ J 7 5 ♠ 4
♡ K 9 6 2 ♡ J 10 7 4
◊ K Q 10 5 ◊ J 9 7 4 2
♣ J 8 ♣ K 10 9

♠ A K Q 6 2
♡ A Q 8 5
◊ A 8 3
♣ 5

West leads ◊K against South's contract of 6 Spades. How can you make this contract against unfavourable position of ♣K?

P–2. Two children

I have two children. At least one of them is a boy. What is the probability that both my children are boys?

My sister also has two children. The older child is a girl. What is the probability that both her children are girls?

B–2. Solution

South finds an ingenious solution:

After the ◊A at trick one, he crossed to the ♣A, ruffed a Club high, and *led a low trump*. The ♠J took a trick to which it wasn't entitled, but declarer now had two entries to dummy, allowing him to set up the Clubs and then get back to them.

P–2. Solution

Since I have two children, at least one of which is a boy, there are three equally probable cases: Boy–Boy, Boy–Girl or Girl–Boy. In only one case are both children boys, so the probability that both are boys is 1–3.

My sister's situation is different. Knowing that the older child is a girl, there are only two equally probable cases: Girl–Girl or Girl–Boy. Therefore the probability that both children are girls is 1–2.

B–3.

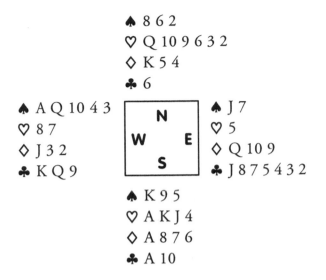

♠ 8 6 2
♡ Q 10 9 6 3 2
◇ K 5 4
♣ 6

♠ A Q 10 4 3
♡ 8 7
◇ J 3 2
♣ K Q 9

♠ J 7
♡ 5
◇ Q 10 9
♣ J 8 7 5 4 3 2

♠ K 9 5
♡ A K J 4
◇ A 8 7 6
♣ A 10

South plays 4 Hearts. West leads ♣K. What is declarer's best line, not knowing the Diamond distribution?

P–3. The d'Alembert paradox

The French mathematician d'Alembert (1717-83) considered the probability of throwing heads at least once when tossing a coin twice. 'There are only three possible cases,' he argued: '(a) Tails appears on the first toss and again on the second toss, (b) Tails appears on the first toss and heads on the second toss, (c) Heads appears on the first toss (therefore in this case there is no longer need to carry out the second toss).'

'It is quite simple,' he stated, 'because there are only three possible cases and as two of these are favourable, the probability is 2/3.' Was his reasoning correct?

B–3. Solution

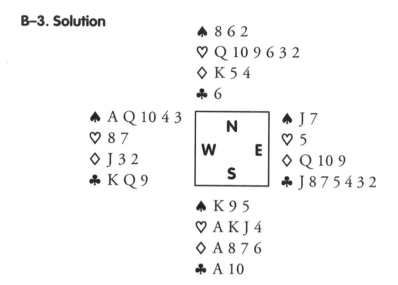

```
              ♠ 8 6 2
              ♡ Q 10 9 6 3 2
              ◇ K 5 4
              ♣ 6
♠ A Q 10 4 3   ┌─────────┐   ♠ J 7
♡ 8 7          │    N    │   ♡ 5
◇ J 3 2        │ W     E │   ◇ Q 10 9
♣ K Q 9        │    S    │   ♣ J 8 7 5 4 3 2
               └─────────┘
              ♠ K 9 5
              ♡ A K J 4
              ◇ A 8 7 6
              ♣ A 10
```

The declarer ducks the ♣K, and discards a Diamond on the ♣A. This line only fails if East has 4 Diamonds.

P–3. Solution

No, his reasoning was incorrect. D'Alembert made the error of not carrying through his analysis far enough. The three cases are not equally likely, and the only way to obtain equally likely cases is, in the third case, to toss the coin again even when the first toss is heads, so that the third case has, in fact, two options and becomes the third and fourth cases. The four possible cases are, therefore, as follows: (a) Tails appears on the first toss and again on the second toss; (b) Tails appears on the first toss and heads on the second toss; (c) Heads appears on the first toss and again on the second toss; (d) Heads appears on the first toss and tails on the second toss.

As there are now proved to be four cases and as three of these are favourable, then the probability of heads at least once is, in fact, 3/4.

B–4.

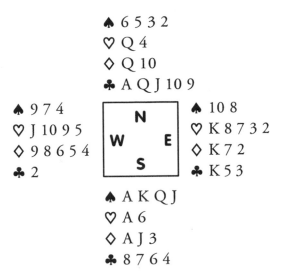

The contract is 6 Clubs by South, opening lead ♡J. Which is the best line of play?

P–4. The aeroplane

An aeroplane flies in a straight line from airport A to airport B, then back in a straight line from B to A. It travels with a constant engine speed, and there is no wind.

Will its travel time for the same round trip be greater, less or the same if, throughout both flights, at the same engine speed, a constant wind blows from A to B?

B–4. Solution

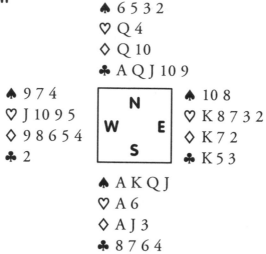

♠ 6 5 3 2
♡ Q 4
◊ Q 10
♣ A Q J 10 9

♠ 9 7 4
♡ J 10 9 5
◊ 9 8 6 5 4
♣ 2

♠ 10 8
♡ K 8 7 3 2
◊ K 7 2
♣ K 5 3

♠ A K Q J
♡ A 6
◊ A J 3
♣ 8 7 6 4

You can only make the contract if the Diamond finesse works. Therefore don't finesse Clubs.

P–4. Solution

Since the wind boosts the plane's speed from A to B and retards it from B to A, one is tempted to suppose that these forces balance each other so that total travel time for the combined flights will remain the same. This is not the case, because the time during which the plane's speed is boosted is shorter than the time during which it is retarded, so the overall effect is one of retardation. The total time in a wind of constant speed and direction, regardless of the speed or direction, is always greater than if there were no wind.

B–5.

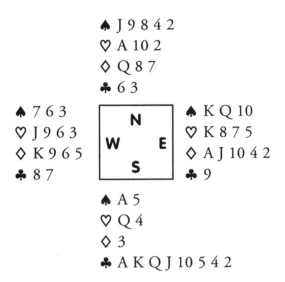

♠ J 9 8 4 2
♡ A 10 2
◇ Q 8 7
♣ 6 3

♠ 7 6 3
♡ J 9 6 3
◇ K 9 6 5
♣ 8 7

♠ K Q 10
♡ K 8 7 5
◇ A J 10 4 2
♣ 9

♠ A 5
♡ Q 4
◇ 3
♣ A K Q J 10 5 4 2

Declarer plays 5 Clubs, opening lead ♡3. Can this contract be made?

P–5. Walking home

John was going home from Brighton. He went half way by train, 15 times as fast as he goes on foot. The second half he went by ox team. He can walk twice as fast as that.

Would he have saved time if he had gone all the way on foot? If so, how much?

B–5. Solution

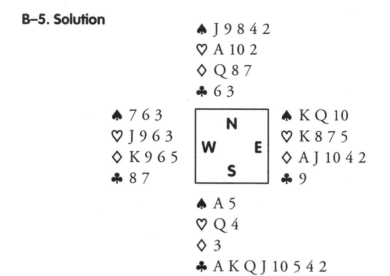

♠ J 9 8 4 2
♡ A 10 2
◊ Q 8 7
♣ 6 3

♠ 7 6 3
♡ J 9 6 3
◊ K 9 6 5
♣ 8 7

♠ K Q 10
♡ K 8 7 5
◊ A J 10 4 2
♣ 9

♠ A 5
♡ Q 4
◊ 3
♣ A K Q J 10 5 4 2

Yes, but only if declarer ducks the opening lead and unblocks the ♡Q on East's King. This will enable declarer to finesse the ♡J to provide the discard of a loser.

P–5. Solution

Yes. He took as much time for the second half of his trip as the whole trip would have taken on foot. So no matter how fast the train was, he lost exactly as much time as he spent on the train.

He would have saved $1/36$ of the time taken by walking all the way.

B–6.

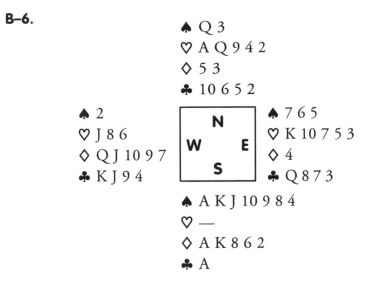

♠ Q 3
♡ A Q 9 4 2
◊ 5 3
♣ 10 6 5 2

♠ 2
♡ J 8 6
◊ Q J 10 9 7
♣ K J 9 4

♠ 7 6 5
♡ K 10 7 5 3
◊ 4
♣ Q 8 7 3

♠ A K J 10 9 8 4
♡ —
◊ A K 8 6 2
♣ A

South plays in 6 Spades. West leads ◊Q. Can this contract be made?

P–6. Three men in the street

Three men met on the street—Mr Black, Mr Grey and Mr White.

'Do you know,' asked Mr Black, 'that between us we are wearing black, grey and white? Yet not one of us is wearing the colour of his name?'

'Why, that's right,' said the man in white.

Can you say who was wearing which colour?

B–6. Solution

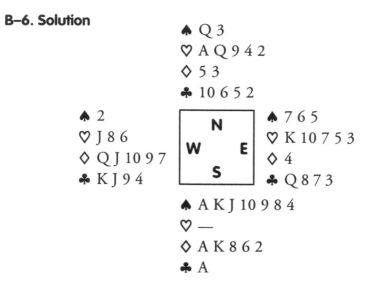

♠ Q 3
♡ A Q 9 4 2
◇ 5 3
♣ 10 6 5 2

♠ 2
♡ J 8 6
◇ Q J 10 9 7
♣ K J 9 4

♠ 7 6 5
♡ K 10 7 5 3
◇ 4
♣ Q 8 7 3

♠ A K J 10 9 8 4
♡ —
◇ A K 8 6 2
♣ A

This contract can only be made if declarer leads a small Diamond at trick two. This is the only line to succeed if Diamonds 5–1.

P–6. Solution

The key is that the man in white is talking to Mr Black, and so cannot be he. Nor can he be Mr White, since nobody is wearing his own colour. So the man in white must be Mr Grey. We can show what we know like this:

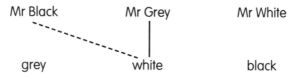

Mr Black Mr Grey Mr White

grey white black

The solid line shows what must be true; the dashed line shows what cannot be true. Mr White cannot be wearing white, so he is in black. That leaves Mr Black wearing grey.

B–7.

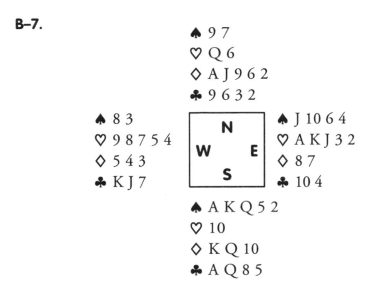

♠ 9 7
♡ Q 6
◊ A J 9 6 2
♣ 9 6 3 2

♠ 8 3
♡ 9 8 7 5 4
◊ 5 4 3
♣ K J 7

♠ J 10 6 4
♡ A K J 3 2
◊ 8 7
♣ 10 4

♠ A K Q 5 2
♡ 10
◊ K Q 10
♣ A Q 8 5

South plays in 4 Spades. West leads ♡9. Can you make your contract against best defence if East plays the ♡J over dummy's ♡6, and returns ♡K?

P–7. Kings and queens

Three playing cards have been removed from an ordinary pack of cards, and placed face up in a horizontal row. To the right of a King there are one or two Queens. To the left of a Queen there are one or two Queens. To the left of a Heart there are one or two Spades. To the right of a Spade there are one or two Spades.

What are the three cards?

B–7. Solution

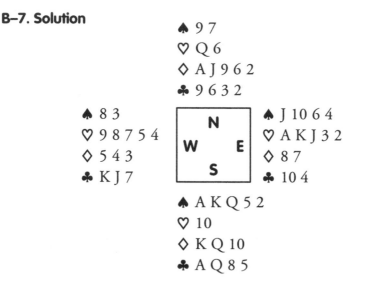

The only line to make the contract is to ruff the ♡K and to lead a small trump from declarer's hand.

P–7. Solution

There are only two arrangements of Kings and Queens which can satisfy the first and second statements, these being KQQ and QKQ. The third and fourth statements are met by only two possible arrangements of Hearts and Spades, these being ♠♠♡ and ♠♡♠. These two sets can be combined in four possible ways as follows:

♠K—♠Q—♡Q ♠K—♡Q—♠Q ♠Q—♠K—♡Q ♠Q—♡K—♠Q

The final set is ruled out because it contains two ♠Q. Since all the other sets consist of ♠K, ♠Q and ♡Q, these must be the three cards on the table. It is not possible to state definitely which position any particular card is in, but the first must be a Spade and the third a Queen.

B–8.

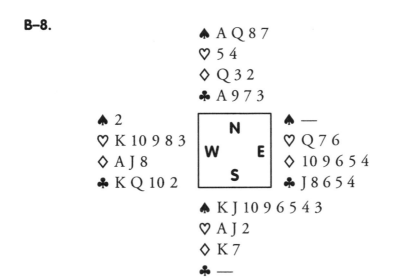

South plays in 6 Spades. West leads ♣K. How do you play your contract?

P–8. Computers

A computer buff called Hacker owns several computers. All but two of them are Apples, all but two of them are Commodores, and all but two of them are IBMs.

How many computers does our friend Hacker own?

B–8. Solution

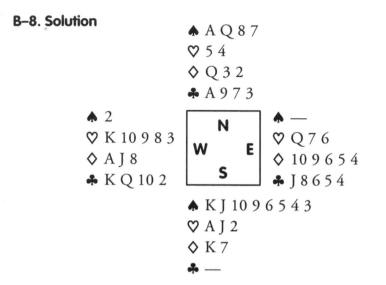

♠ A Q 8 7
♡ 5 4
◊ Q 3 2
♣ A 9 7 3

♠ 2
♡ K 10 9 8 3
◊ A J 8
♣ K Q 10 2

♠ —
♡ Q 7 6
◊ 10 9 6 5 4
♣ J 8 6 5 4

♠ K J 10 9 6 5 4 3
♡ A J 2
◊ K 7
♣ —

Don't take the ♣K with the Ace, but play low and ruff. Then play ◊7 after having drawn trumps. Whether East goes up with the Ace or not, you have made your contract.

P–8. Solution

Three computers.

B–9.

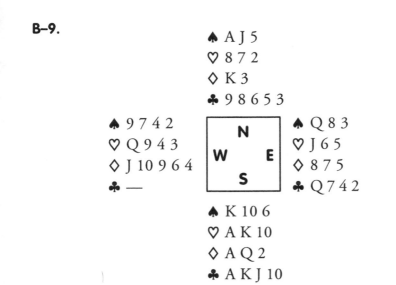

```
              ♠ A J 5
              ♡ 8 7 2
              ◊ K 3
              ♣ 9 8 6 5 3
♠ 9 7 4 2          ┌─────────┐          ♠ Q 8 3
♡ Q 9 4 3          │    N    │          ♡ J 6 5
◊ J 10 9 6 4       │ W     E │          ◊ 8 7 5
♣ —                │    S    │          ♣ Q 7 4 2
                   └─────────┘
              ♠ K 10 6
              ♡ A K 10
              ◊ A Q 2
              ♣ A K J 10
```

South is in 6 no trumps. West leads the ◊J. Can you make your contract without having to guess the Spade finesse?

P–9. The handicap race

Mel and Sid race each other in a 100–yard dash. Mel wins by 10 yards. They decide to race again, but this time, to make things fairer, Mel begins 10 yards behind the starting line. Assuming they both run with the same constant speed as before, who wins this time, Mel or Sid? Or is it a draw?

B–9. Solution

♠ A J 5
♡ 8 7 2
◊ K 3
♣ 9 8 6 5 3

♠ 9 7 4 2
♡ Q 9 4 3
◊ J 10 9 6 4
♣ —

♠ Q 8 3
♡ J 6 5
◊ 8 7 5
♣ Q 7 4 2

♠ K 10 6
♡ A K 10
◊ A Q 2
♣ A K J 10

The winning play is a surprising one. You must lead the ♠10, running the card. If the 10 wins, you will have three Spade tricks and can play Clubs from the top. If instead the 10 loses to East's Queen, the ♠A and ♠J will be available as entries to the dummy. You will be able to take two Club finesses, then return to dummy with the third entry to enjoy the thirteenth Club. This clever play would be unnecessary in a contract of 6 Clubs, since the thirteenth Club (now a trump) would not require an entry.

P–9. Solution

Mel wins again. In the second race, after Sid has gone 90 yards, Mel will have gone 100, and they will be alongside each other. There are 10 more yards to run, and since Mel is the faster runner, he will finish first.

B–10.

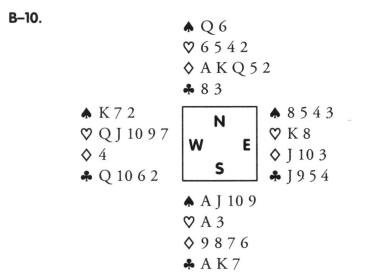

♠ Q 6
♡ 6 5 4 2
◊ A K Q 5 2
♣ 8 3

♠ K 7 2
♡ Q J 10 9 7
◊ 4
♣ Q 10 6 2

♠ 8 5 4 3
♡ K 8
◊ J 10 3
♣ J 9 5 4

♠ A J 10 9
♡ A 3
◊ 9 8 7 6
♣ A K 7

South plays in 3 no-trumps. West leads the ♡Q. East plays the ♡K. You duck. East continues with the ♡8. Can you make your contract?

P–10. The South Pole

Base to explorer at the South Pole: 'What's the temperature?'

'Minus 40 degrees,' said the explorer.

'Is that Centigrade or Fahrenheit?' asked base.

'Put down Fahrenheit,' said the explorer. 'I don't expect it will matter.'

Why did he say that?

B–10. Solution

```
                    ♠ Q 6
                    ♡ 6 5 4 2
                    ◊ A K Q 5 2
                    ♣ 8 3
   ♠ K 7 2                        ♠ 8 5 4 3
   ♡ Q J 10 9 7                   ♡ K 8
   ◊ 4                            ◊ J 10 3
   ♣ Q 10 6 2                     ♣ J 9 5 4
                    ♠ A J 10 9
                    ♡ A 3
                    ◊ 9 8 7 6
                    ♣ A K 7
```

If you don't look closely, you might have thought 'piece of cake'—5 Diamonds, ♡A, 3 Clubs, 1 Spade, 10 tricks. But then you notice that the Diamonds are blocked.

After cashing ◊A and ◊K, lead a Heart, and throw one of your Diamonds. West can only have 3 Hearts left, and whatever is played thereafter you have 9 tricks.

P–10. Solution

−40° Centigrade = −40° Fahrenheit.

B–11.

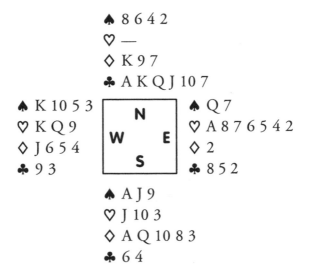

The contract is 6 Diamonds by South. West leads ♡K. You ruff in dummy with the ◊7. What is your next move?

P–11. Guinness or stout

Two strangers enter a pub. The bartender asks them what they would like.

First man says, 'I'll have a bottle of stout,' and puts 50p down on the counter.

Bartender: 'Guinness at 50p, or Jubilee at 45p?'

First man: 'Jubilee.'

Second man says, 'I'll have a bottle of stout,' and puts 50p on the counter. Without asking him, the publican gives him Guinness.

How did the bartender know what the second man was drinking?

B–11. Solution

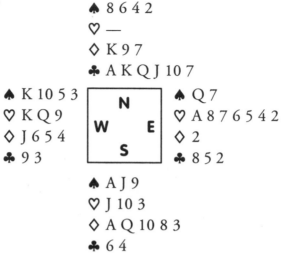

```
              ♠ 8 6 4 2
              ♡ —
              ◊ K 9 7
              ♣ A K Q J 10 7
♠ K 10 5 3                      ♠ Q 7
♡ K Q 9                        ♡ A 8 7 6 5 4 2
◊ J 6 5 4                      ◊ 2
♣ 9 3                          ♣ 8 5 2
              ♠ A J 9
              ♡ J 10 3
              ◊ A Q 10 8 3
              ♣ 6 4
```

Lead the ◊9, and run it, unless East covers with the Jack. This guarantees the contract even if trumps are 4–1.

P–11. Solution

The second man put the 50p down in some combination of change—for instance, 4 × 10p and 2 × 5p coins—so that he could have put just 45p down if he had wanted Jubilee.

B–12.

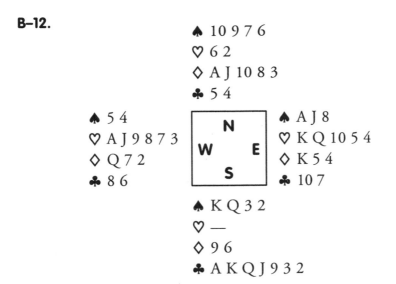

♠ 10 9 7 6
♡ 6 2
◇ A J 10 8 3
♣ 5 4

♠ 5 4
♡ A J 9 8 7 3
◇ Q 7 2
♣ 8 6

♠ A J 8
♡ K Q 10 5 4
◇ K 5 4
♣ 10 7

♠ K Q 3 2
♡ —
◇ 9 6
♣ A K Q J 9 3 2

South plays in 5 Spades. West leads the ♡A. South ruffs and leads the Queen of trumps. East takes with the Ace, and returns a Heart. Can declarer make his contract?

P–12. The gamblers

Since his retirement, Ian and his wife Emma had become addicted to gambling. Ian had a good pension and substantial savings which enabled them to visit casinos around the world. However, after a few months, they had lost so much money that they decided to join Gamblers Anonymous. As a last fling, they booked a suite near a casino for a seven-day stay. As fate would have it, they won a five-figure amount during the first three days. As often happens, they made friends with gamblers at the same tables, and in the intervals, over drinks, exchanged pleasantries and gambling anecdotes. On the fourth day something happened, as a result of which Ian and Emma, and some of their new-found friends—though not all—died a slow death. No crime or disease was involved.

What do you think had happened?

B–12. Solution

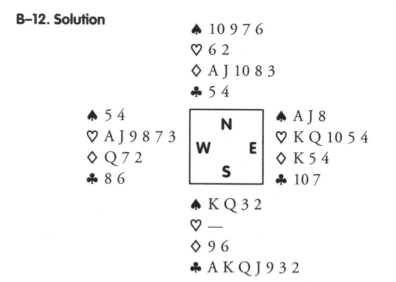

<pre>
 ♠ 10 9 7 6
 ♡ 6 2
 ◊ A J 10 8 3
 ♣ 5 4
 ♠ 5 4 ♠ A J 8
 ♡ A J 9 8 7 3 N ♡ K Q 10 5 4
 ◊ Q 7 2 W E ◊ K 5 4
 ♣ 8 6 S ♣ 10 7
 ♠ K Q 3 2
 ♡ —
 ◊ 9 6
 ♣ A K Q J 9 3 2
</pre>

Not against best defence. Declarer's best line is to ruff the second Heart with a King instead of the ♠3, otherwise he would have to cross to the ◊A to draw the last trump, and he would lose 2 trumps and 1 Diamond. However, if East holds up the Spades, the contract is defeated.

P–12. Solution

Ian and Emma had booked a suite aboard a luxury cruise liner. On the fourth day there was an explosion in the engine room, as a result of which the ship sank. Some passengers were saved, though many drowned, including Ian and Emma.

B–13.

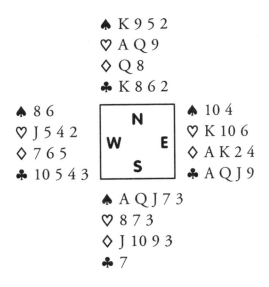

♠ K 9 5 2
♡ A Q 9
◇ Q 8
♣ K 8 6 2

♠ 8 6
♡ J 5 4 2
◇ 7 6 5
♣ 10 5 4 3

♠ 10 4
♡ K 10 6
◇ A K 2 4
♣ A Q J 9

♠ A Q J 7 3
♡ 8 7 3
◇ J 10 9 3
♣ 7

South plays 4 Spades. West leads the ♣3. Dummy's King was played, and East took the trick with his Ace. This time, try to find the defence which will defeat the contract.

P–13. How fast?

The Baja Road Race is 1,000 miles long. At the half-way point, Speedy Gonzales calculates that he has been driving at an average speed of 50 miles per hour. How fast should he drive the second half of the race if he wants to attain an overall average of 100 miles per hour?

B–13. Solution

The only return by East to defeat the contract is the ♡6 to ensure a Heart trick before Hearts are discarded by Diamonds.

P–13. Solution

Speedy will have to drive at an infinite speed in order to average 100 miles per hour for the course. He must drive the whole 1,000 miles in 10 hours to attain the required speed, but he has already used up his 10 hours to drive the first half of the course. He will have to finish the race in zero time!

B–14.

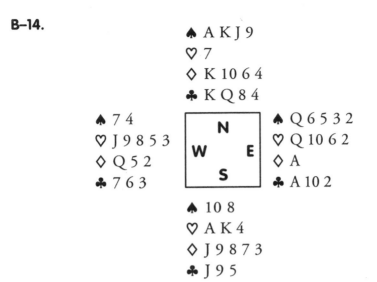

South plays in 5 Diamonds. West led the ♠7, and dummy's Ace took the trick, South playing ♠8. The declarer entered his hand with the ♡K, and led the ◊J. West played low, and so did the table, East's singleton Ace making. How can East defeat the contract?

P–14. Buttons and boxes

Imagine you have three boxes, one containing two red buttons, one containing two green buttons, and the third, one red button and one green button. The boxes are labelled according to their contents—RR, GG and RG. However, the labels have been switched so that each box is now incorrectly labelled.

Without looking inside, you may take one button at a time out of any box. Using this process of sampling, what is the smallest number of buttons needed to determine the contents of all three boxes?

B–14. Solution

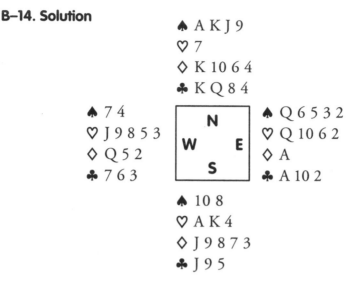

♠ A K J 9
♡ 7
◇ K 10 6 4
♣ K Q 8 4

♠ 7 4
♡ J 9 8 5 3
◇ Q 5 2
♣ 7 6 3

♠ Q 6 5 3 2
♡ Q 10 6 2
◇ A
♣ A 10 2

♠ 10 8
♡ A K 4
◇ J 9 8 7 3
♣ J 9 5

East's return of the ♠Q will defeat the contract. Declarer cannot prevent an overruff of Spades by West.

P–14. Solution

You can ascertain the contents of all three boxes by removing just one button. The solution depends on the fact that the labels on all three boxes are incorrect. Take a button from the box labelled RG. Assume that the button removed is red. You now know that the other button in this box must be red also, otherwise the label would be correct. Since you have identified which box contains two red buttons, you can work out immediately the contents of the box marked GG because you know it cannot contain two green buttons since its label has to be wrong. It cannot contain two red buttons for you have already identified that box. Therefore it must contain one red and one green button. The third box, of course, must then be the one with the two green buttons. The same reasoning works if the first button you take from the RG box happens to be green instead of red.

B–15.

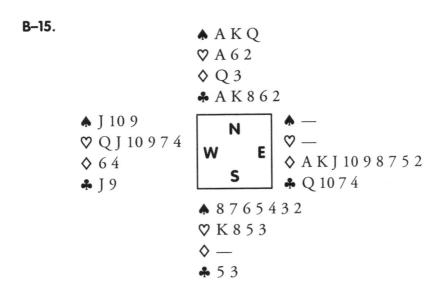

♠ A K Q
♡ A 6 2
◊ Q 3
♣ A K 8 6 2

♠ J 10 9
♡ Q J 10 9 7 4
◊ 6 4
♣ J 9

♠ —
♡ —
◊ A K J 10 9 8 7 5 2
♣ Q 10 7 4

♠ 8 7 6 5 4 3 2
♡ K 8 5 3
◊ —
♣ 5 3

South plays 6 Spades. West leads the ♡Q. A low card is played from dummy. East throws the ◊J, and South's King wins. Declarer plays a trump to the table's Queen, West throwing the 9♡, and East discarding the ◊2. How can declarer avoid losing 2 Hearts?

P–15. A unique number

The following number is the only one of its kind. Can you figure out what is so special about it?

$$8,549,176,320$$

B–15. Solution

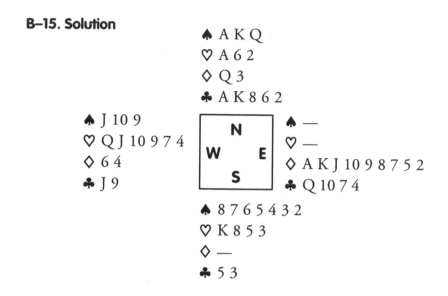

♠ A K Q
♡ A 6 2
♢ Q 3
♣ A K 8 6 2

♠ J 10 9
♡ Q J 10 9 7 4
♢ 6 4
♣ J 9

♠ —
♡ —
♢ A K J 10 9 8 7 5 2
♣ Q 10 7 4

♠ 8 7 6 5 4 3 2
♡ K 8 5 3
♢ —
♣ 5 3

Declarer draws one round of trumps, plays the ♢Q from dummy, discarding a Club. He can now ruff one Club without being overruffed by West. He now draws trumps, ruffs another Club, re-enters dummy with the ♡K, discarding 2 losing Hearts.

P–15. Solution

It is the only one that contains the numerals in alphabetical order.

B–16.

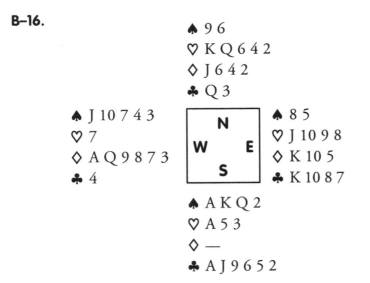

♠ 9 6
♡ K Q 6 4 2
◊ J 6 4 2
♣ Q 3

♠ J 10 7 4 3
♡ 7
◊ A Q 9 8 7 3
♣ 4

♠ 8 5
♡ J 10 9 8
◊ K 10 5
♣ K 10 8 7

♠ A K Q 2
♡ A 5 3
◊ —
♣ A J 9 6 5 2

Contract is 6 Clubs played by South. West leads the ♡7. Even with the location of every card known to declarer, this is an extremely difficult contract to make against best defence. Go ahead and try.

P–16. One—two—three

What is the next row of digits? I could not solve it, but my 12-year-old granddaughter did. It is that kind of puzzle.

1									
1	1								
2	1								
1	2	1	1						
1	1	1	2	2	1				
3	1	2	2	1	1				
1	3	1	1	2	2	2	1		
1	1	1	3	2	1	3	2	1	1
?	?	?	?	?	?	?	?	?	...

B–16. Solution

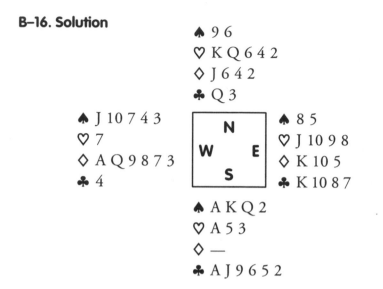

Take the lead in dummy. Play the ♣3, and finesse South's ♣9. Then play ♡A and ♡K, and ruff the ♡4. Cash the ♠A and ♠K, and ruff the ♠2 with dummy's ♠Q. For East to overruff would be bad defence, therefore East discards a Diamond. Now comes the key play. Declarer led the last Heart from dummy. For East to ruff would once again be losing defence, and a Diamond is discarded instead, while declarer discards the remaining high Spade, so that his last 4 cards are all trumps. A Diamond is led from dummy, and East can only take one trick.

P–16. Solution

Each line of numbers describes the line above it. Starting with 1, the second line describes the first as one 1, in numbers: 1 1, then 2 (two) 1s, then 1-2, 1-1, etc. The next row is:

$$3 \quad 1 \quad 1 \quad 3 \quad 1 \quad 2 \quad 1 \quad 1 \quad 1 \quad 3 \quad 1 \quad 2 \quad 2 \quad 1$$

B–17.

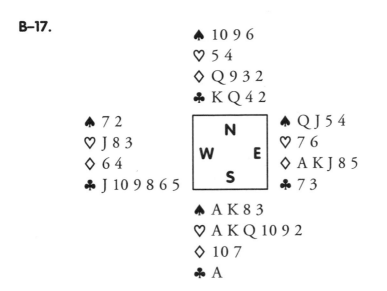

\spadesie 10 9 6
\heartsuit 5 4
\diamondsuit Q 9 3 2
\clubsuit K Q 4 2

\spadesuit 7 2
\heartsuit J 8 3
\diamondsuit 6 4
\clubsuit J 10 9 8 6 5

\spadesuit Q J 5 4
\heartsuit 7 6
\diamondsuit A K J 8 5
\clubsuit 7 3

\spadesuit A K 8 3
\heartsuit A K Q 10 9 2
\diamondsuit 10 7
\clubsuit A

South plays in 4 Hearts. West leads the ◊6. Dummy plays low, and East takes the trick with his Jack. He cashed the ◊K. Can East-West defeat the contract, and if so how?

P–17. The prisoners' test

A wicked king amuses himself by putting three prisoners to a test. He takes three hats from a box containing three red hats and two white hats. He puts one hat on each prisoner, leaving the remaining two in the box. He informs the men of the total number of hats of each colour, then says, 'The first man who can correctly determine the colour of the hat on his own head, and explain his reasoning, will immediately be set free. But if any of you answers incorrectly, you will be executed on the spot.'

The first man looks at the other two, and says, 'I don't know.' The second man looks at the hats on the first and third man, and finally says, 'I don't know the colour of my hat either.' The third man is at something of a disadvantage: he is blind. But he is also clever. He thinks for a few seconds and then announces, correctly, the colour of his hat. What colour hat is the blind man wearing, and how did he know?

B–17. Solution

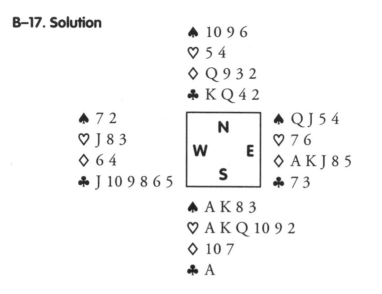

East should continue with ◊5. Declarer's best card is a high ruff, intending to follow with ♣A, ♠A, ♠K, throwing in West with the Jack of trumps to give the declarer 2 Spade discards on Clubs. West can defeat this plan by unblocking the ♡J at trick three.

P–17. Solution

The man is wearing a red hat. His reasoning is as follows: 'The first man did not see two white hats. If he had, he woud have known immediately that he was wearing a red hat because there are only two white hats. The second man, aware that the first did not see two white hats, needed only to look at me; if he had seen a white hat on me, he would have known he was wearing a red hat (otherwise the first man would not have been stumped). Since he didn't know, he could not have seen a white hat on me. Therefore, my hat must be red.'

B–18.

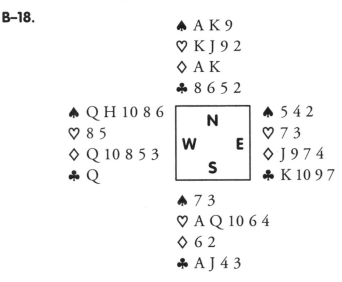

♠ A K 9
♡ K J 9 2
◇ A K
♣ 8 6 5 2

♠ Q H 10 8 6
♡ 8 5
◇ Q 10 8 5 3
♣ Q

♠ 5 4 2
♡ 7 3
◇ J 9 7 4
♣ K 10 9 7

♠ 7 3
♡ A Q 10 6 4
◇ 6 2
♣ A J 4 3

South plays in 6 Hearts. West leads ♠Q, taken by dummy's King. The declarer draws trumps in two rounds; cashes dummy's ♠A and ruffs dummy's last Spade; cashes ◇A, ◇K; and leads dummy's ♣2 and ducks it. Can this contract be defeated, and if so, how?

P–18. The square table

A square table is constructed with an obstruction in the middle of it, so that when four people are seated, one on each side, each can see his neighbours to right and left but not the person seated directly across. The four people seated at this table were told to raise their hands if, when looking to the right and left, they saw at least one woman. They were also told to announce the sex of the one person whom they could not see, if they could figure it out.

Since, as a matter of fact, all four people were women, each raised her hand, but then several minutes went by before one of them announced that she was certain that the person seated opposite her was a woman.

How could she logically have come to that conclusion?

B–18. Solution

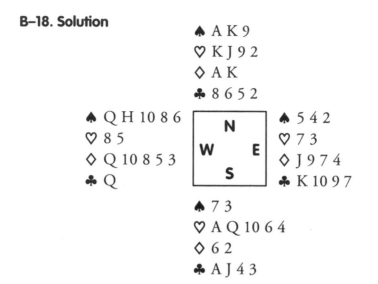

♠ A K 9
♡ K J 9 2
◇ A K
♣ 8 6 5 2

♠ Q H 10 8 6
♡ 8 5
◇ Q 10 8 5 3
♣ Q

♠ 5 4 2
♡ 7 3
◇ J 9 7 4
♣ K 10 9 7

♠ 7 3
♡ A Q 10 6 4
◇ 6 2
♣ A J 4 3

The contract can be defeated by East covering the ♣2 with the King. If he does not, West takes the trick, is end-played, and has to give declarer a ruff and discard.

P–18. Solution

Let's examine the problem from the point of view of any one of the women. Initially, since she is a woman, she reasons that her neighbours' hands would be raised regardless of whether the unseen individual was a man or a woman. But after further thought it occurs to her that if the person opposite was actually a man, he would have known immediately that the person sitting opposite him was a woman because his neighbours would have raised their hands only for that reason. Since the unseen person did not make this announcement, it could only be because she was a woman.

B–19.

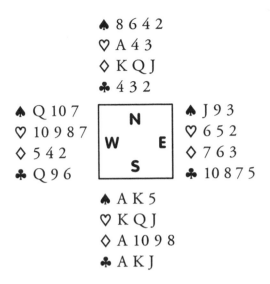

The contract is 6NT by South. Opening lead ♡10. There is only one line giving you the best chance to make the contract. If you don't know the distributions, which is it?

P–19. Strange symbols

When Alice first stepped through the looking glass, she saw this strange set of symbols on a sign:

'What does it mean?' she wondered. 'It looks like a secret code or the alphabet of some foreign language.' Alice studied the sign a little longer, and then had a thought: 'It's a sequence with a definite pattern.'

When you recognise the pattern you should have no difficulty in drawing the next figure in the sequence. What is the next symbol?

B–19. Solution

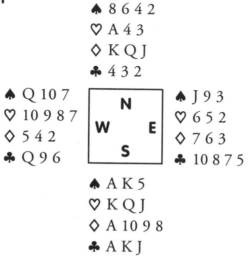

```
            ♠ 8 6 4 2
            ♡ A 4 3
            ◇ K Q J
            ♣ 4 3 2

♠ Q 10 7        N        ♠ J 9 3
♡ 10 9 8 7               ♡ 6 5 2
◇ 5 4 2      W     E     ◇ 7 6 3
♣ Q 9 6                  ♣ 10 8 7 5
                 S
            ♠ A K 5
            ♡ K Q J
            ◇ A 10 9 8
            ♣ A K J
```

You have 11 tricks on top. If either Spades break 3–3 or the ♣Q is on side you are home. To test both and keep your options open, play a small Spade from both hands.

P–19. Solution

Alice realised that, behind a looking glass, everything is reflected. The symbols stand for the numbers, one to seven. The right-hand side of each symbol is the correct numeral, the left-hand side is its mirror image. The next symbol in the sequence, then, is a back-to-back figure 8.

B–20.

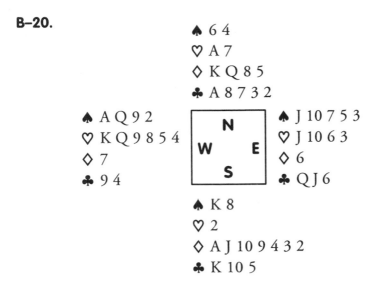

♠ 6 4
♥ A 7
♦ K Q 8 5
♣ A 8 7 3 2

♠ A Q 9 2
♥ K Q 9 8 5 4
♦ 7
♣ 9 4

♠ J 10 7 5 3
♥ J 10 6 3
♦ 6
♣ Q J 6

♠ K 8
♥ 2
♦ A J 10 9 4 3 2
♣ K 10 5

Declarer is in 5 Diamonds. West leads ♥K. Can you make the contract against best defence?

P–20. Manhattan and Yonkers

Sharon lives in Riverdale, near the train station. She has two boyfriends, Wayne in Yonkers and Kevin in midtown Manhattan. To visit Wayne, she takes a train from the northbound platform; to visit Kevin she takes a train from the southbound platform. Since Sharon likes both boys equally well, she simply gets on the first train that comes along. In this way she lets chance determine whether she goes to Yonkers or Grand Central. Sharon reaches the station at a random moment every Saturday afternoon. The northbound and southbound trains arrive at the station equally often—every 10 minutes. Yet, for some reason, she finds herself spending most of her time with Wayne in Yonkers. In fact, on average, she goes there 9 times out of 10.

Can you explain why the odds are so heavily in Wayne's favour.

B–20. Solution

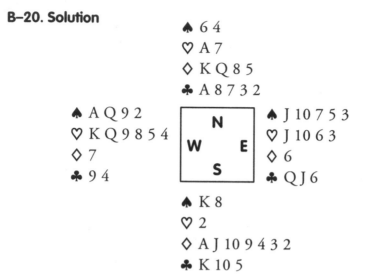

```
                    ♠ 6 4
                    ♡ A 7
                    ◇ K Q 8 5
                    ♣ A 8 7 3 2

    ♠ A Q 9 2           N        ♠ J 10 7 5 3
    ♡ K Q 9 8 5 4                ♡ J 10 6 3
    ◇ 7             W       E     ◇ 6
    ♣ 9 4               S        ♣ Q J 6

                    ♠ K 8
                    ♡ 2
                    ◇ A J 10 9 4 3 2
                    ♣ K 10 5
```

The contract is unbreakable if you duck the ♡K, but use the ♡A to discard a Club, establishing the suit to discard the Spade losers.

P–20. Solution

Although the trains to Yonkers and Manhattan arrive equally often—every 10 minutes—it so happens that the Manhattan train always arrives one minute after the Yonkers train. Thus, the Manhattan train will be the first to arrive only if Sharon happens to arrive at the station during this one-minute interval. If she enters the station at any other time, during the 9-minute interval, the Yonkers train will arrive first. Since Sharon's arrival is random, the odds are 9 to 1 in favour of Yonkers.

2. Wizard's Delight

The spying game

In war, as in industrial espionage, the main problem is to avoid detection when transmitting messages. Microdots and invisible ink are old hat, and new methods are devised all the time. Paul Goodwin was employed on a top-secret project concerning isotopes, and his problem was to transmit a message to his principals abroad. Coded messages were too dangerous and therefore unthinkable. After much consideration, he devised what he considered to be a foolproof method.

There are 26 letters in the alphabet. As any message would also contain punctuation marks and spaces (between words), there is a total of about 40 symbols. Paul assigned a two-digit number to each, starting with 01 for A, 02 for B, and so on until he reached 38 for a full stop and 39 for a space between words. ('ISOTOPE MASS' would, for instance, read: 09 19 15 20 15 16 05 39 13 01 19 19.) With the help of his computer, Paul translated the message into one long number.

The reader is now asked to permit some intellectual licence. By putting a decimal point before the number, we can consider the whole code to be expressed as the length in metres of a bar made of precious metal (to avoid any chemical reaction with the atmosphere). This bar would have a length of more than 9 but less than 10 cm. Let us assume that Paul has the means to cut the bar to the required length, which would require fantastic precision. Let us also assume that the recipient of the bar, having equally precise measuring equipment, would obtain the same decimal number and decode the secret message.

Assuming that the precision needed for this operation were available, would it work, at least in theory? If not, can you think of a procedure which would make it theoretically viable?

The spying game. Solution

No, the operation would not work theoretically. A minute variation in temperature would completely demolish the code, due to thermal expansion.

You could cope with the problem of thermal expansion by converting the decimal into a fraction and cutting the bar in two pieces, one to represent the numerator and the other the denominator. This would be purely a mathematical solution, inasmuch as thermal expansion would affect both bars, leaving the ratio, and therefore the fraction, unaffected.

On a physical level it would not even work theoretically. The problem is the tremendously small distances that one is soon involved in. Every letter added to the message would involve a hundredfold increase in accuracy. Sending messages with only two letters (e.g. OK) would probably be feasible, for this would require an accuracy of one-tenth of a millimetre.

To send a five-letter message (e.g. ATOMS) would require an accuracy which is about half the diameter of an atom of iron. As you cannot have half an atom, the sending of such a message by this method is impossible.

Some readers might think that lengthening the bar would provide a viable solution. Ignoring the logistic problem connected with sending a long bar, let us re-examine the position.

Remember that to send the message ISOTOPE MASS, we have to transmit the number 09191520151605391301199. Let us suppose we send a bar whose length is this number of millimetres. How long is the bar?

91,915,201,516,053,913,011,919 millimetres = 10^{23} mm = 10^{17} km, which is 600 million times farther than the distance (93 million miles) between the Earth and the sun.

B–21.

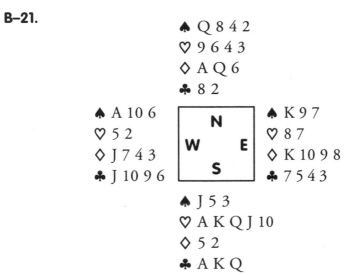

♠ Q 8 4 2
♡ 9 6 4 3
◇ A Q 6
♣ 8 2

♠ A 10 6 ♠ K 9 7
♡ 5 2 ♡ 8 7
◇ J 7 4 3 ◇ K 10 9 8
♣ J 10 9 6 ♣ 7 5 4 3

♠ J 5 3
♡ A K Q J 10
◇ 5 2
♣ A K Q

South plays 4 Hearts. West leads ♣J. Can the contract be made against best defence?

P–21. The slow horses

An aged and, it appears, somewhat eccentric king wants to pass his throne on to one of his two sons. He decrees that his sons will race their horses, and that the son who owns the slower horse shall become king. The sons, each fearing that the other will cheat by having his horse go less fast than it is capable of, ask a wise man's advice. With just two words, the wise man ensures that the race will be fair.

What does he say?

B–21. Solution

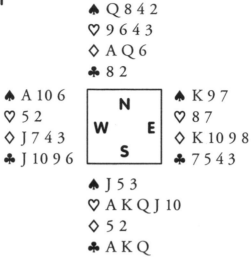

♠ Q 8 4 2
♡ 9 6 4 3
◊ A Q 6
♣ 8 2

♠ A 10 6
♡ 5 2
◊ J 7 4 3
♣ J 10 9 6

♠ K 9 7
♡ 8 7
◊ K 10 9 8
♣ 7 5 4 3

♠ J 5 3
♡ A K Q J 10
◊ 5 2
♣ A K Q

You must avoid having to tackle the Spade suit yourself. After drawing trumps, discard the ◊6 on the third Club and play ◊A and ◊Q. No matter who holds the ◊K, the contract is now safe.

P–21. Solution

'Change horses.'

B–22.

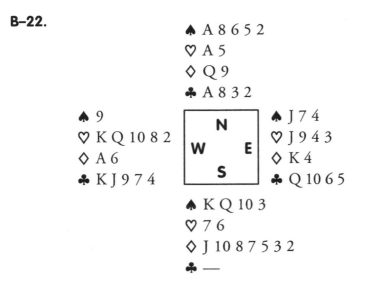

♠ A 8 6 5 2
♡ A 5
◊ Q 9
♣ A 8 3 2

♠ 9
♡ K Q 10 8 2
◊ A 6
♣ K J 9 7 4

♠ J 7 4
♡ J 9 4 3
◊ K 4
♣ Q 10 6 5

♠ K Q 10 3
♡ 7 6
◊ J 10 8 7 5 3 2
♣ —

South plays in 4 Spades. West leads the ♡K. Can this contract be made?

P–22. The will

Daniel Greene was killed in a car crash while on his way to the maternity hospital where his wife, Sheila, was about to give birth. He had recently made a new will, in which he stated that, should the baby be a boy, his estate was to be divided two-thirds to his son and one-third to Sheila; if the baby were a girl, then she as to receive a quarter of the estate and Sheila the other three-quarters.

In the event Sheila gave birth to twins—a boy and a girl. How best should Daniel's estate be divided so as to carry out his intention?

B–22. Solution

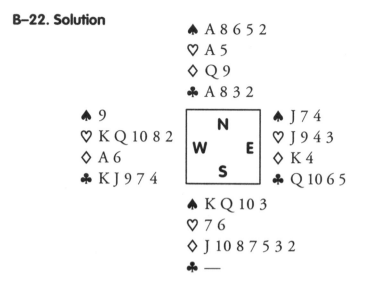

```
            ♠ A 8 6 5 2
            ♡ A 5
            ◊ Q 9
            ♣ A 8 3 2
♠ 9                          ♠ J 7 4
♡ K Q 10 8 2      N          ♡ J 9 4 3
◊ A 6          W     E       ◊ K 4
♣ K J 9 7 4       S          ♣ Q 10 6 5
            ♠ K Q 10 3
            ♡ 7 6
            ◊ J 10 8 7 5 3 2
            ♣ —
```

You take the lead with the ♡A. If you then play the ♣A to discard the losing Hearts, the contract can no longer be made, as your hand's trump holding will be shortened twice. Instead, start establishing your Diamonds. East takes the ◊K, cashes a Heart, but you can now only be forced once before Diamonds are established.

P–22. Solution

Daniel Greene's evident intention was that his estate be divided 2:1 between his son and his widow, or 1:3 between his daughter and his widow. These ratios can be preserved by giving the son six-tenths of the estate, the daughter one-tenth, and his widow, Sheila, three-tenths. Thus Sheila receives half of the boy's share and 3 times the girl's share.

B–23.

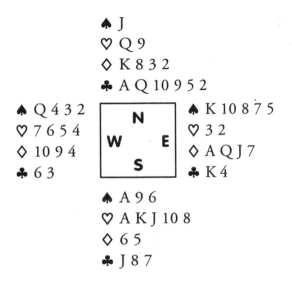

♠ J
♡ Q 9
◊ K 8 3 2
♣ A Q 10 9 5 2

♠ Q 4 3 2
♡ 7 6 5 4
◊ 10 9 4
♣ 6 3

♠ K 10 8 7 5
♡ 3 2
◊ A Q J 7
♣ K 4

♠ A 9 6
♡ A K J 10 8
◊ 6 5
♣ J 8 7

South plays 4 Hearts. West leads ♠2. Can you avoid losing one Spade, one Club and two Diamonds, for one down?

P–23. A logic riddle

In olden days, students of logic were given the following type of problem:
 If half of 5 were 3, what would one-third of 10 be?

B–23. Solution

```
              ♠ J
              ♡ Q 9
              ◇ K 8 3 2
              ♣ A Q 10 9 5 2

♠ Q 4 3 2                      ♠ K 10 8 7 5
♡ 7 6 5 4         N            ♡ 3 2
◇ 10 9 4      W       E        ◇ A Q J 7
♣ 6 3             S            ♣ K 4

              ♠ A 9 6
              ♡ A K J 10 8
              ◇ 6 5
              ♣ J 8 7
```

Yes, by ducking the first Spade trick, to cut communication between East and West. This is the safest line. However, as cards lie, an immediate Club finesse will also succeed.

P–23. Solution

The answer is 4. The problem can be written by way of analogy as follows:

$$\frac{5}{2} : 3 = \frac{10}{3} : x$$

An alternative reasoning goes as follows:

If $2\frac{1}{2} = 3$, then $10 = 12$

Therefore $\frac{1}{3}$ of 10 would be 4.

B–24.

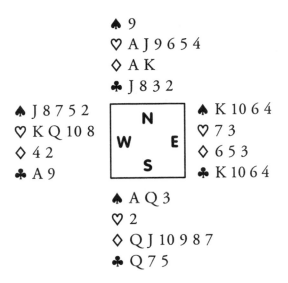

♠ 9
♡ A J 9 6 5 4
♢ A K
♣ J 8 3 2

♠ J 8 7 5 2
♡ K Q 10 8
♢ 4 2
♣ A 9

♠ K 10 6 4
♡ 7 3
♢ 6 5 3
♣ K 10 6 4

♠ A Q 3
♡ 2
♢ Q J 10 9 8 7
♣ Q 7 5

South plays in 3 No Trumps. West leads the ♠5. Can you make the contract against best defence?

P–24. Water level problem

An ice cube is floating in a beaker of water, with the entire system at 0° Centigrade (32°F). Just enough heat is applied to melt the ice cube without raising the temperature of the system.

What happens to the water level in the beaker? Does it rise, fall, or stay the same?

B–24. Solution

```
              ♠ 9
              ♡ A J 9 6 5 4
              ◊ A K
              ♣ J 8 3 2

♠ J 8 7 5 2         N         ♠ K 10 6 4
♡ K Q 10 8    W         E     ♡ 7 3
◊ 4 2               S         ◊ 6 5 3
♣ A 9                         ♣ K 10 6 4

              ♠ A Q 3
              ♡ 2
              ◊ Q J 10 9 8 7
              ♣ Q 7 5
```

You cannot make your contract against best defence, though you are likely to make it if you play well. If you take East's ♠K with the Ace, you will be down as the Diamond suit is blocked. If you duck, and East continues Spades, as he is likely to do, you can discard ◊A, ◊K in dummy and make 3 No Trumps. If however East switches, the contract is bound to fail.

P–24. Solution

The water level neither rises nor falls: it stays the same. The reason an ice cube floats is because its volume has expanded during crystallisation. Its weight remains the same as the weight of the water that formed it. Since a floating body displaces its weight, when the ice cube has melted it will provide the same amount of water as the volume of water it displaced when it was frozen.

B–25.

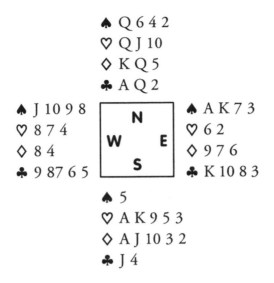

♠ Q 6 4 2
♡ Q J 10
◇ K Q 5
♣ A Q 2

♠ J 10 9 8
♡ 8 7 4
◇ 8 4
♣ 9 87 6 5

♠ A K 7 3
♡ 6 2
◇ 9 7 6
♣ K 10 8 3

♠ 5
♡ A K 9 5 3
◇ A J 10 3 2
♣ J 4

South plays in 6 Hearts. West leads ♠J. Can you make your contract?

P–25. Avoiding the train

A man was walking down a railway track when he saw an express train speeding towards him. To avoid it, he jumped off the track, but before he jumped he ran 10 feet towards the train.

Why?

B–25. Solution

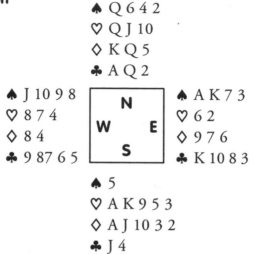

♠ Q 6 4 2
♡ Q J 10
◊ K Q 5
♣ A Q 2

♠ J 10 9 8
♡ 8 7 4
◊ 8 4
♣ 9 87 6 5

♠ A K 7 3
♡ 6 2
◊ 9 7 6
♣ K 10 8 3

♠ 5
♡ A K 9 5 3
◊ A J 10 3 2
♣ J 4

It appears that you will fail, losing one Spade and the ♣K. However, you have sufficient entries for a dummy reversal play, ruffing 3 Spades in your hand, re-entering dummy with the ♣A to draw the last trump on which you discard the losing Club.

P–25. Solution

The stretch of track the man was walking on was over a railway bridge or in a tunnel, and he was much nearer the end closer to the train than the farther end.

B–26.

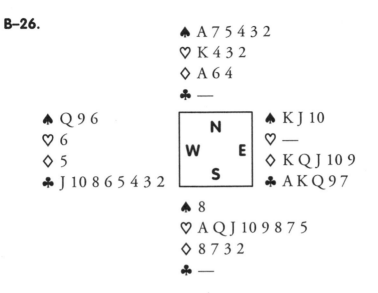

♠ A 7 5 4 3 2
♡ K 4 3 2
◇ A 6 4
♣ —

♠ Q 9 6
♡ 6
◇ 5
♣ J 10 8 6 5 4 3 2

♠ K J 10
♡ —
◇ K Q J 10 9
♣ A K Q 9 7

♠ 8
♡ A Q J 10 9 8 7 5
◇ 8 7 3 2
♣ —

Contract is 6 Hearts by South. West leads ◇5. Is there a way to make it?

P–26. The prisoner's choice

A prisoner was about to be executed but was promised his freedom if he drew a silver ball from one of two identical urns. He was allowed to distribute 50 silver and 50 gold balls between the two urns any way he liked. The urns were then going to be shuffled around out of his sight, and he was to pick one urn and draw one ball at random from that urn.

How did the prisoner maximise his chances of success? If he had put equal numbers of silver and gold balls into one of the urns, the other urn would also contain equal numbers of silver and gold balls, and thus the probability of his drawing a silver ball would have been 1 in 2.

Can you improve these chances, and if so how?

B–26. Solution

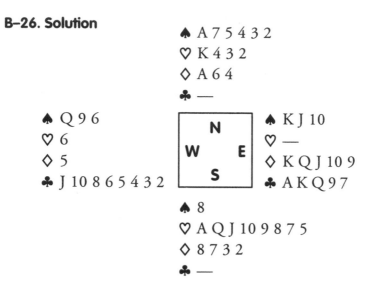

♠ A 7 5 4 3 2
♡ K 4 3 2
◊ A 6 4
♣ —

♠ Q 9 6
♡ 6
◊ 5
♣ J 10 8 6 5 4 3 2

♠ K J 10
♡ —
◊ K Q J 10 9
♣ A K Q 9 7

♠ 8
♡ A Q J 10 9 8 7 5
◊ 8 7 3 2
♣ —

This contract seems impossible as there are not enough entries to dummy to establish Spades and enjoy the discards of 3 losing Diamonds. However, there is a way:

Take the lead with ◊A. Play ♠A and ruff a Spade. Now lead ♡5, and let West win the trick with ♡6. Whatever West plays now gives you the contract.

P–26. Solution

The prisoner believed he could improve his chances by distributing the gold and silver balls unevenly between the two urns. In fact, he decided his best strategy was to place just one silver ball in one of the urns, and the remaining 49 silver balls and all 50 gold balls in the second urn. This way, if his random choice of urn brought him the second urn to pick from, his chances of picking a life-saving silver ball were only slightly worse than 1–2 (49–99), while if he was lucky enough to choose the first urn, he was certain to escape death.

B–27.

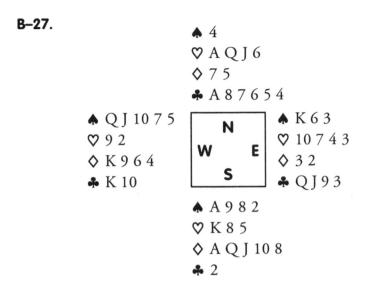

♠ 4
♥ A Q J 6
♦ 7 5
♣ A 8 7 6 5 4

♠ Q J 10 7 5
♥ 9 2
♦ K 9 6 4
♣ K 10

♠ K 6 3
♥ 10 7 4 3
♦ 3 2
♣ Q J 9 3

♠ A 9 8 2
♥ K 8 5
♦ A Q J 10 8
♣ 2

South plays in 5 Diamonds. West leads the ♠Q. How do you plan to make the contract?

P–27. Counter colours

A bag contains one counter, which may be either black or white. A second counter, which is definitely white, is put into the bag. The bag is shaken, and one counter taken out, which proves to be white. What is the probability of the next counter coming out of the bag also being white?

B–27. Solution

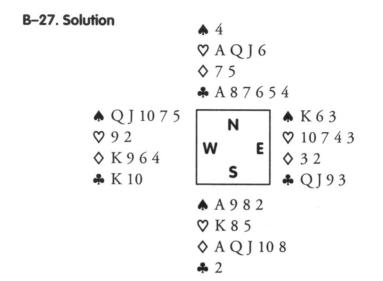

♠ 4
♡ A Q J 6
◇ 7 5
♣ A 8 7 6 5 4

♠ Q J 10 7 5
♡ 9 2
◇ K 9 6 4
♣ K 10

♠ K 6 3
♡ 10 7 4 3
◇ 3 2
♣ Q J 9 3

♠ A 9 8 2
♡ K 8 5
◇ A Q J 10 8
♣ 2

If you take the lead with your ♠A, you will lose control, and the contract will be defeated. However, if you duck the lead, the defence is powerless, and you will make one Spade ruff, the ♠A, 4 Diamonds, 4 Hearts and the ♣A, a total of 11 tricks.

P–27. Solution

Most people think that because the state of the bag after the removal of the white counter is exactly the same as it was before the white counter was put in, the probability must be ½. This is not, however, the case.

The odds of the original counter (call it x) in the bag being black or white are even. Adding a white counter (call this y) makes the odds of the bag containing 2W or WB even. After one white counter is removed, three possibilities present themselves: (a) the counter removed was x, in which case the one left is certainly white; (b) the counter removed was y, and the one left is white; (c) the counter removed was y, and the one left is black. In two out of the above three possible cases, the counter left in the bag is white; so the odds are 2:1 in favour of the second counter being white.

B–28.

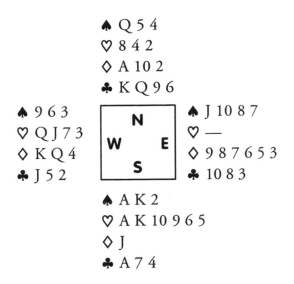

♠ Q 5 4
♡ 8 4 2
♦ A 10 2
♣ K Q 9 6

♠ 9 6 3
♡ Q J 7 3
♦ K Q 4
♣ J 5 2

♠ J 10 8 7
♡ —
♦ 9 8 7 6 5 3
♣ 10 8 3

♠ A K 2
♡ A K 10 9 6 5
♦ J
♣ A 7 4

The contract is 6 Hearts by South. West leads the ♦K. Can you make your contract in spite of the unfavourable trump position?

P–28. The kings

Six playing cards are lying face-down on the table. Two, and only two, of them are Kings, but you don't know which. You pick two cards at random and turn them face-up. Which is more likely:

 a) That there will be at least one King among the two cards; or

 b) That there will be no King among the two cards?

B–28. Solution

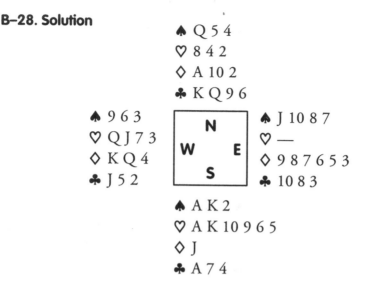

♠ Q 5 4
♥ 8 4 2
♦ A 10 2
♣ K Q 9 6

♠ 9 6 3
♥ Q J 7 3
♦ K Q 4
♣ J 5 2

N W E S

♠ J 10 8 7
♥ —
♦ 9 8 7 6 5 3
♣ 10 8 3

♠ A K 2
♥ A K 10 9 6 5
♦ J
♣ A 7 4

The lead is taken by the ♦A. The ♥A as second trick reveals the trump position. You now shorten your trump holding by ruffing 2 Diamonds, eliminate side suites, and end play West by playing the ♥10.

P–28. Solution

Let the 6 cards be numbered 1 to 6, and assume that the two Kings are cards 5 and 6. Now list all the different combinations of 2 cards that can be picked from 6, as follows:

1–2	2–3	3–4	4–5	5–6
1–3	2–4	3–5	4–6	
1–4	2–5	3–6		
1–5	2–6			
1–6				

Note that the Kings (cards 5 and 6) appear in 9 out of the 15 pairs. Since each pair is equally likely, this means that in the long run a King will be turned up in 9 out of every 15 tries. So the chances of getting a King are three-fifths. This of course is better than one-half, so the answer is that (a) is more likely.

B–29.

```
              ♠ 5 4 3
              ♡ 8 6 2
              ◇ 8 6 5 4 3
              ♣ 10 7

    ♠ —              ♠ Q J 9 7
    ♡ J 9 7 3        ♡ Q 10 4
    ◇ 10 7           ◇ J 9 2
    ♣ A K 9 6 5 4 3  ♣ J 8 2

              ♠ A K 10 8 6 2
              ♡ A K 5
              ◇ A K Q
              ♣ Q
```

South plays in 4 Spades. West leads the ♣A and continues with ♣K. Can you make the contract against best defence?

P–29. Crossing the desert

A small aeroplane carrying three men has to make an emergency landing in the middle of the desert. The men decide that their best chance for survival is for each of them to set out across the desert in a different direction, in the hope that one of them will be able to reach civilisation and get help for the others. Their supplies include five full bottles of water, five half-full, and five empty bottles.

Since water-carrying capacity is important should a man reach an oasis, they wish to divide both the water supply and the number of bottles equally among themselves. How can they achieve this?

B–29. Solution

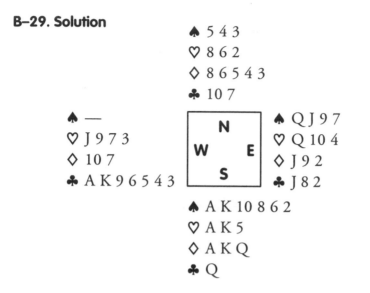

♠ 5 4 3
♡ 8 6 2
◊ 8 6 5 4 3
♣ 10 7

♠ —
♡ J 9 7 3
◊ 10 7
♣ A K 9 6 5 4 3

♠ Q J 9 7
♡ Q 10 4
◊ J 9 2
♣ J 8 2

♠ A K 10 8 6 2
♡ A K 5
◊ A K Q
♣ Q

If South has ruffed the second Club with ♠2 he will be unable to redeem his error. The Club is ruffed with the ♠6, and ♠A reveals the position. Now 3 rounds of Diamonds are followed by 3 rounds of Hearts. In at trick 9, with ♡Q East can do no better than play ♠Q, but declarer counters this move by following with the ♠8. If East now plays a Club, South must ruff with his carefully preserved ♠2 and take the trick in dummy with ♠4. East's second trump trick is now lost to declarer's tenace.

It will not help East to unblock his Hearts and allow West to play the 13th Heart. In this event dummy ruffs, and when East overruffs with an honour—it would only delay the endplay to discard his Club—South underruffs with ♠8, still preserving that vital ♠2.

P–29. Solution

There is enough water for 7½ full bottles. There are 15 bottles altogether. Therefore each man will end up with 2½ full bottles and 2½ empty bottles. However, half an empty bottle is the same as half a full bottle, leading to each man having 2 full bottles, one half-full bottle, and 2 empty bottles.

B–30.

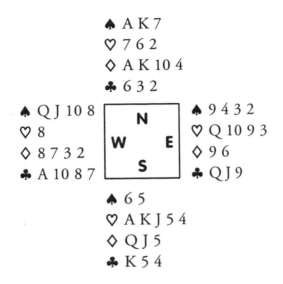

♠ A K 7
♡ 7 6 2
◇ A K 10 4
♣ 6 3 2

♠ Q J 10 8
♡ 8
◇ 8 7 3 2
♣ A 10 8 7

♠ 9 4 3 2
♡ Q 10 9 3
◇ 9 6
♣ Q J 9

♠ 6 5
♡ A K J 5 4
◇ Q J 5
♣ K 5 4

South plays in 4 Hearts. West leads ♠Q. You take the lead with the ♠K. What do you do next to make your contract?

P–30. Fast fly

A Ferrari is travelling at 30 miles per hour on a head-on collision course with a Maserati, which is being driven at a leisurely 20 miles per hour. When the two cars are exactly 50 miles apart, a very fast fly leaves the front bumper of the Ferrari and travels towards the Maserati at 100 miles per hour. When it reaches the Maserati, it instantly reverses direction and flies back to the Ferrari, and continues winging back and forth between the rapidly approaching cars.

At the moment the two cars collide, what is the total distance the fly has covered?

B–30. Solution

```
              ♠ A K 7
              ♡ 7 6 2
              ◊ A K 10 4
              ♣ 6 3 2

♠ Q J 10 8                    ♠ 9 4 3 2
♡ 8              N            ♡ Q 10 9 3
◊ 8 7 3 2    W       E        ◊ 9 6
♣ A 10 8 7       S            ♣ Q J 9

              ♠ 6 5
              ♡ A K J 5 4
              ◊ Q J 5
              ♣ K 5 4
```

You play the ♡2 and cover East's ♡3 with ♡4. No matter that it loses to ♡8. When declarer regains the lead, a top Heart reveals the trump position, and the remainder of East's trumps can be picked up without loss. The crucial factor is the East is denied the lead; thus he can never attack South's unprotected ♣K—until South has drawn trumps and taken one discard.

P–30. Solution

At first glance it may seem that a horrendous calculation, involving calculus, is necessary to solve this: the sum of an infinite series of numbers that get smaller and smaller as the cars approach each other. But if you focus on time rather than distance, a solution is easy. The cars are 50 miles apart and travelling towards each other at a combined speed of 50 miles per hour, so they will meet in one hour. In that hour, a fly that flies at 100 miles per hour will naturally travel 100 miles.

B–31.

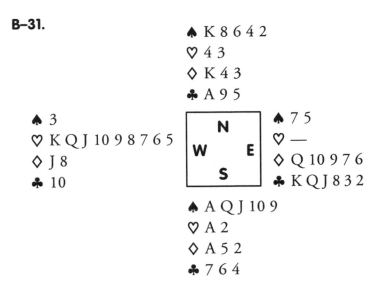

The contract is 4 Spades by South. West leads the ♡K. You appear to have four losers. Is there a way to make the contract?

P–31. Card games

Jack and Jill are playing cards for a stake of £1 a game. At the end of the evening, Jack has won three games, and Jill has won £3.

How many games did they play?

B–31. Solution

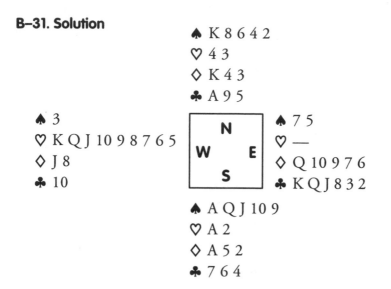

♠ K 8 6 4 2
♡ 4 3
◇ K 4 3
♣ A 9 5

♠ 3
♡ K Q J 10 9 8 7 6 5
◇ J 8
♣ 10

♠ 7 5
♡ —
◇ Q 10 9 7 6
♣ K Q J 8 3 2

♠ A Q J 10 9
♡ A 2
◇ A 5 2
♣ 7 6 4

Yes, but only if you play the correct card to the first trick. East ruffs the opening lead, and you have to jettison your ♡A to prepare the ground for a rare double ruff and discard.

You win any return by East, probably the ♣K, draw trumps, play ◇A and ◇K, and exit with a Heart. West, who has only Hearts left, is forced to give you the opportunity to discard a Diamond from dummy and a Club from your hand. West, still on lead, has to play another Heart which is ruffed in dummy, while the last Club in your hand is discarded.

P–31. Solution

Nine. Jack wins three games and thus gains £3. Jill has to win back this £3, which takes another three games, then win a further three games.

B–32.

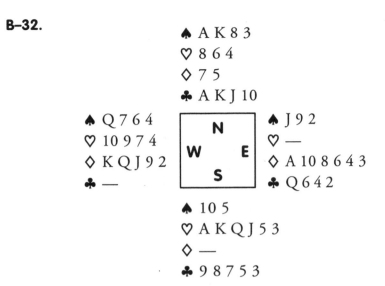

♠ A K 8 3
♡ 8 6 4
◊ 7 5
♣ A K J 10

♠ Q 7 6 4
♡ 10 9 7 4
◊ K Q J 9 2
♣ —

♠ J 9 2
♡ —
◊ A 10 8 6 4 3
♣ Q 6 4 2

♠ 10 5
♡ A K Q J 5 3
◊ —
♣ 9 8 7 5 3

South is in 6 Hearts, and West opens with the ◊K. How can the contract be made against best defence?

P–32. Which games?

I have three friends. Two play football, two play tennis, and two play golf. The one who does not play golf does not play tennis, and the one who does not play tennis does not play football.

Which games does each friend play?

B–32. Solution

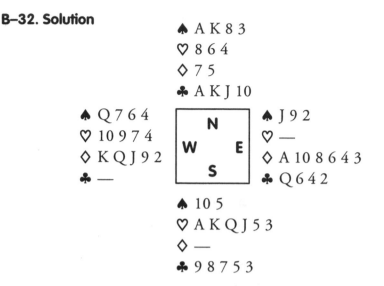

♠ A K 8 3
♡ 8 6 4
◊ 7 5
♣ A K J 10

♠ Q 7 6 4
♡ 10 9 7 4
◊ K Q J 9 2
♣ —

♠ J 9 2
♡ —
◊ A 10 8 6 4 3
♣ Q 6 4 2

♠ 10 5
♡ A K Q J 5 3
◊ —
♣ 9 8 7 5 3

This contracts looks easy, but it conceals a trap. You ruff the opening lead and draw 4 trumps. The critical card is dummy's discard on the fourth Heart. You have three options: a small Spade, the ♣10, and the remaining Diamond. Only the Diamond discard will secure the contract. If you discard the Club, East will decline to take the ♣J, and the suit will be blocked.

P–32. Solution

One friend plays none of the games, so the other two must each play all three.

B–33.

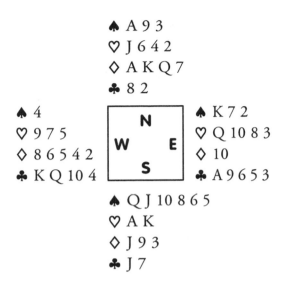

♠ A 9 3
♡ J 6 4 2
◇ A K Q 7
♣ 8 2

♠ 4
♡ 9 7 5
◇ 8 6 5 4 2
♣ K Q 10 4

♠ K 7 2
♡ Q 10 8 3
◇ 10
♣ A 9 6 5 3

♠ Q J 10 8 6 5
♡ A K
◇ J 9 3
♣ J 7

South plays 4 Spades. West leads the ♣K, East overtaking with the Ace and returning the ◇10. How would you play the hand?

P–33. What day is it?

When the day after tomorrow will be yesterday, today will be as far from Sunday as today was from Sunday when the day before yesterday is tomorrow.

What day is it today?

B–33. Solution

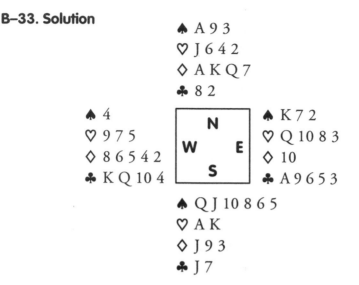

After winning the Diamond switch, cash the ♡A and ♡K. Play trump to the Ace and play the ♡J, discarding your remaining Club. East has now no entry to West, to give him a Diamond ruff.

P–33. Solution

Today is Sunday. The drawing below will assist:

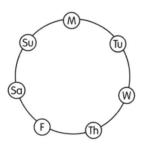

Choose a day at random, say Tuesday, then:
1. When the day after tomorrow (Thursday) is yesterday (Monday), 4 days will have elapsed.
2. When the day before yesterday (Sunday) is tomorrow (Wednesday), 3 days will have elapsed.
3. Today will therefore be 7 days from Sunday, i.e. Sunday.

B–34.

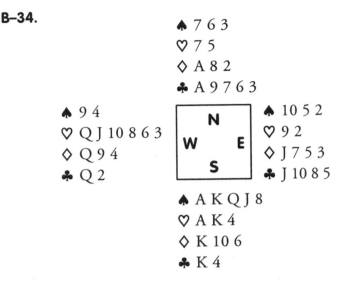

 ♠ 7 6 3
 ♡ 7 5
 ◊ A 8 2
 ♣ A 9 7 6 3

♠ 9 4 ♠ 10 5 2
♡ Q J 10 8 6 3 ♡ 9 2
◊ Q 9 4 ◊ J 7 5 3
♣ Q 2 ♣ J 10 8 5

 ♠ A K Q J 8
 ♡ A K 4
 ◊ K 10 6
 ♣ K 4

South plays 6 Spades. West leads ♡Q. Can you make your contract with the unfavourable Club distribution?

P–34. Problem age

The day before yesterday, Peter was 17. Next year he will be 20.

How do you explain this?

B–34. Solution

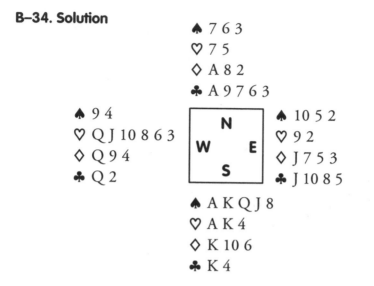

```
              ♠ 7 6 3
              ♡ 7 5
              ◊ A 8 2
              ♣ A 9 7 6 3
♠ 9 4                        ♠ 10 5 2
♡ Q J 10 8 6 3    N          ♡ 9 2
◊ Q 9 4       W       E      ◊ J 7 5 3
♣ Q 2             S          ♣ J 10 8 5
              ♠ A K Q J 8
              ♡ A K 4
              ◊ K 10 6
              ♣ K 4
```

The best idea is to employ a rare technique known as 'trading ruffs'. You win the Heart lead, cross to the ◊A and lead a second Heart towards the King. You then lead a third round of Hearts, throwing a Diamond from dummy. Nothing can prevent you from ruffing a Diamond in dummy for the 12th trick.

P–34. Solution

The statement was made on 1 January. Peter's birthday is 31 December. He was 17 the day before yesterday. Yesterday, the last day of last year, was his 18th birthday. He will be 19 on the last day of this year, and 20 on the last day of next year.

B–35.

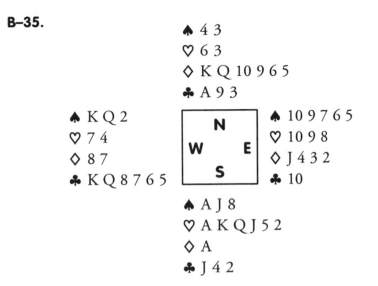

<pre>
 ♠ 4 3
 ♡ 6 3
 ◊ K Q 10 9 6 5
 ♣ A 9 3
 ♠ K Q 2 ♠ 10 9 7 6 5
 ♡ 7 4 N ♡ 10 9 8
 ◊ 8 7 W E ◊ J 4 3 2
 ♣ K Q 8 7 6 5 S ♣ 10
 ♠ A J 8
 ♡ A K Q J 5 2
 ◊ A
 ♣ J 4 2
</pre>

The contract is 6 Hearts by South. West leads the ♣K. How would you play to make the contract?

P–35. Three points on a hemisphere

Three points are selected at random on a sphere's surface. What is the probability that they all lie in the same hemisphere? Assume that the great circle, bordering a hemisphere, is part of the hemisphere.

B–35. Solution

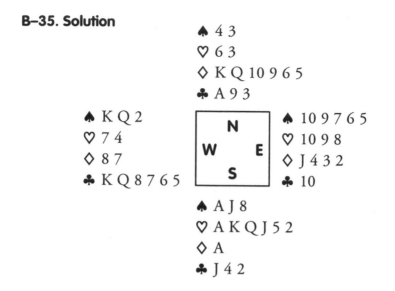

♠ 4 3
♡ 6 3
◊ K Q 10 9 6 5
♣ A 9 3

♠ K Q 2
♡ 7 4
◊ 8 7
♣ K Q 8 7 6 5

♠ 10 9 7 6 5
♡ 10 9 8
◊ J 4 3 2
♣ 10

♠ A J 8
♡ A K Q J 5 2
◊ A
♣ J 4 2

The recommended play is to win with Dummy's ♣A. When the 10 appears from East, you unblock the Jack from the South hand. You can then draw trumps, cash the ◊A, and lead a Club towards dummy's 9. Nothing can prevent you from reaching dummy's Diamond winners and pitching your two losing Spades.

P–35. Solution

The probability is 1 (complete certainty). Any three points on a sphere must be on a hemisphere, as three points always form a plane.

B–36.

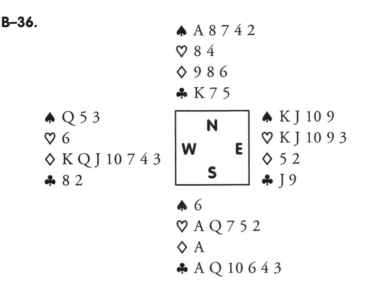

♠ A 8 7 4 2
♡ 8 4
♢ 9 8 6
♣ K 7 5

♠ Q 5 3
♡ 6
♢ K Q J 10 7 4 3
♣ 8 2

♠ K J 10 9
♡ K J 10 9 3
♢ 5 2
♣ J 9

♠ 6
♡ A Q 7 5 2
♢ A
♣ A Q 10 6 4 3

You, South, play in 6 Clubs. West leads the ♢K. Can you make your contract?

P–36. The bridge

A-town and B-town are two villages connected by a bridge spanning a river. At the end of a war, the occupying forces installed a sentry in the middle of the bridge to prevent the inhabitants of A-town and B-town from visiting each other. All means of transport having been requisitioned, the only access from village to village is by foot over the bridge, which would take 10 minutes. The sentry is under strict orders to come out of his bunker every 5 minutes, and send anyone trying to cross back to his own village, if necessary by force of arms. Michael in A-town is desperate to visit his girlfriend in B-town. Is there a way?

B–36. Solution

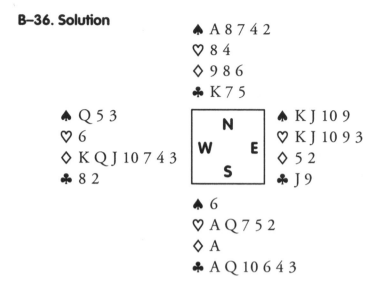

```
                ♠ A 8 7 4 2
                ♡ 8 4
                ◊ 9 8 6
                ♣ K 7 5

♠ Q 5 3          ┌─────────┐          ♠ K J 10 9
♡ 6              │    N    │          ♡ K J 10 9 3
◊ K Q J 10 7 4 3 │ W     E │          ◊ 5 2
♣ 8 2            │    S    │          ♣ J 9
                 └─────────┘
                ♠ 6
                ♡ A Q 7 5 2
                ◊ A
                ♣ A Q 10 6 4 3
```

Cross to the ♠A and take the Heart finesse, and play a low Heart. You could then win the trump switch with the Queen, crossruff in the red suits, draw trumps, and claim the slam.

P–36. Solution

Michael set out for B-town as soon as he saw the sentry disappear into his bunker. Timing his progress, he walked for almost 5 minutes. He then turned round and started running back towards A-town. The sentry emerged and, seeing Michael running towards A-town, ordered him to 'return' to B-town.

B-37.

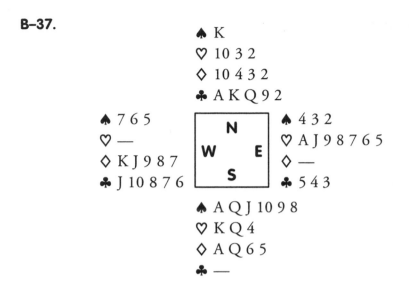

Sitting South, you play in 6 Spades. West leads the ♣J. How do you play?

P-37. Red, white and blue

This is a famous paradox which has caused a great deal of argument and disbelief from many who cannot accept the correct answer.

Four balls are placed in a hat. One is white, one is blue, and the other two are red. The bag is shaken, and someone draws two balls from the hat. He looks at the two balls and announces that at least one of them is red.

What are the chances that the other ball he has drawn out is also red?

B–37. Solution

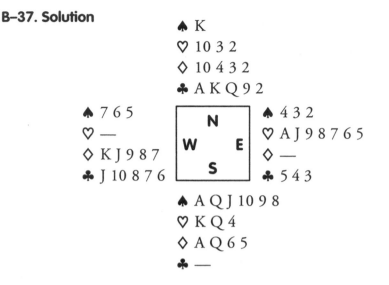

♠ K
♡ 10 3 2
◊ 10 4 3 2
♣ A K Q 9 2

♠ 7 6 5
♡ —
◊ K J 9 8 7
♣ J 10 8 7 6

♠ 4 3 2
♡ A J 9 8 7 6 5
◊ —
♣ 5 4 3

♠ A Q J 10 9 8
♡ K Q 4
◊ A Q 6 5
♣ —

Can you see the amazing play that is required at trick 1 to make the contract? Declarer must win the Club lead in dummy and discard the ◊Q. He now draws trumps in three rounds, throwing a Club and a Diamond from dummy. When he continues with the ♡K, East has to duck, or a subsequent lead from the ♡J will give an entry to dummy. Declarer continues with a low Diamond from hand. West must insert an honour to prevent dummy gaining the lead, but now he is end-played. Whether he plays a Diamond from the King or a Club from the 10, declarer will have 12 tricks.

P–37. Solution

There are six possible pairings of the two balls withdrawn: Red+Red, Red+White, White+Red, Red+Blue, Blue+Red, White+Blue. We know that the White+Blue combination has not been drawn. This leaves five possible combinations remaining. Therefore the chances that the Red+Red pairing has been drawn are 1 in 5.

B–38.

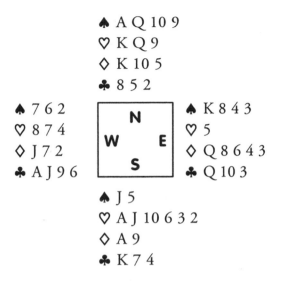

South plays in 4 Hearts. West leads the 4 of trumps. How would you have played the hand?

P–38. Even tread

I keep one spare tyre in my car. Last year, I drove 10,000 miles, and rotated the tyres at intervals so that, by the end of the year, each of the five tyres had been used for the same number of miles.

For how many miles was each tyre used?

B–38. Solution

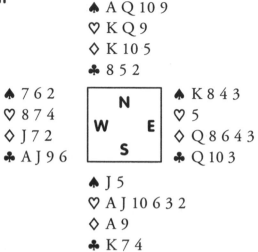

$$
\begin{array}{c}
\spadesuit \text{ A Q 10 9} \\
\heartsuit \text{ K Q 9} \\
\diamondsuit \text{ K 10 5} \\
\clubsuit \text{ 8 5 2}
\end{array}
$$

♠ 7 6 2　　♠ K 8 4 3
♡ 8 7 4　　♡ 5
◊ J 7 2　　◊ Q 8 6 4 3
♣ A J 9 6　　♣ Q 10 3

♠ J 5
♡ A J 10 6 3 2
◊ A 9
♣ K 7 4

South saw that if he took a losing Spade finesse, a Club return would put the contract at risk. A better idea would be to set up dummy's Spades without allowing East to gain the lead. He won the trump lead in dummy, and played a Diamond to the 9. West won and returned a trump, again taken in the dummy. Now came a Diamond to the Ace and the ♠J. South overtook with dummy's ♠A, and threw his last Spade on the ◊K. He could now lead the ♠Q for a ruffing finesse. Even if this lost to the King with West, the contract would be secure.

P–38. Solution

Each tyre was used for four-fifths of the total mileage: four-fifths of 10,000 miles = 8,000 miles per tyre.

B–39.

```
              ♠ 9 7 6
              ♡ 8 5 4
              ◇ A 9 2
              ♣ A 6 4 3
♠ K Q J 5      ┌─────────┐      ♠ 10 8 3 2
♡ 9 7 6        │    N    │      ♡ 10 3
◇ J 10 5 4     │ W     E │      ◇ Q 6
♣ Q 5          │    S    │      ♣ K J 10 8 7
               └─────────┘
              ♠ A 4
              ♡ A K Q J 2
              ◇ K 8 7 3
              ♣ 9 2
```

South plays in 4 Hearts. How would you tackle this hand after West leads the ♠K?

P–39. Missing elevation

From the front elevation and the plan below, can you find the side elevation and describe the object?

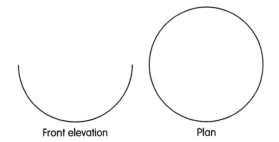

Front elevation Plan

B–39. Solution

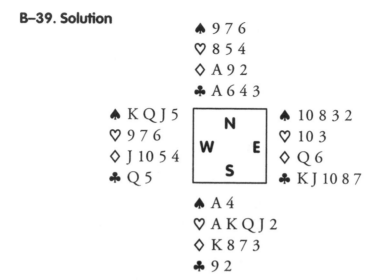

```
            ♠ 9 7 6
            ♡ 8 5 4
            ◇ A 9 2
            ♣ A 6 4 3

♠ K Q J 5    N      ♠ 10 8 3 2
♡ 9 7 6             ♡ 10 3
◇ J 10 5 4  W    E  ◇ Q 6
♣ Q 5        S      ♣ K J 10 8 7

            ♠ A 4
            ♡ A K Q J 2
            ◇ K 8 7 3
            ♣ 9 2
```

If Diamonds were 3–3, it would be easy. What can you do when they are 4–2? Suppose you draw two rounds of trumps, then play Ace, King and another Diamond. That's no good. The defender who wins the third round will either play another round of trumps, removing dummy's last trump, or (if partner has the last trump) give his partner a Diamond ruff. The potentially dangerous moment will occur when the defenders take their Diamond trick. To prevent them doing any damage, you should let them win the *first* round of Diamonds. At trick 3 you play a Diamond to the 9 and East's Queen. You ruff his Spade return, and only now play your two rounds of trumps. You are going to make the contract! When you play the ◇A and ◇K, East shows out on the third round but has no trump with which to ruff. You can now ruff your last Diamond with impunity.

P–39. Solution

This is a wire figure, in the form of an ellipse, bent at its smaller 'diameter'.

Side elevation

B–40.

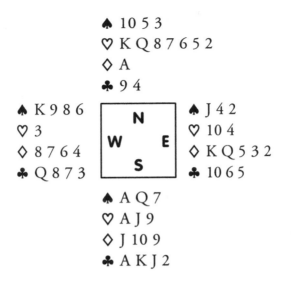

The contract is 6 Hearts by South following a transfer bid. Which line of play gives the declarer the best chance, after West leads the ♦7?

P–40. Two bridges

Imagine two bridges that are exactly alike except that every dimension in one is twice as large as in the other. For example, the large bridge is two times longer, its structure members are two times thicker, and so forth.

Which bridge is stronger, or is their strength the same?

B–40. Solution

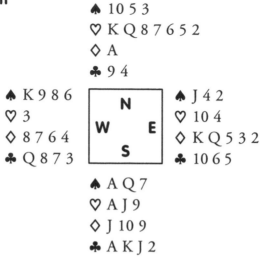

```
              ♠ 10 5 3
              ♡ K Q 8 7 6 5 2
              ◊ A
              ♣ 9 4
♠ K 9 8 6              ♠ J 4 2
♡ 3          N        ♡ 10 4
◊ 8 7 6 4  W   E      ◊ K Q 5 3 2
♣ Q 8 7 3    S        ♣ 10 6 5
              ♠ A Q 7
              ♡ A J 9
              ◊ J 10 9
              ♣ A K J 2
```

Declarer won with the Ace, crossed to the Ace of trumps, and ruffed a Diamond. He then cashed the two top Clubs and ruffed a third Club with the King. A trump to the Jack drew the last trump, and declarer then led the ♣J. When West produced the ♣Q, the contract was assured. Declarer threw a losing Spade from dummy, and West was endplayed. He had to lead a Spade into South's tenace or to concede a ruff-and-discard. If West had shown out on the last Club, declarer would ruff in dummy and lead the ♠10. The contract would succeed if West held the ♠J (he would then be endplayed) or if East held the ♠K.

P–40. Solution

The smaller bridge is twice as strong. If a steel girder, B, is twice the size of girder A in every dimension, it will be twice as strong as girder A but it will weigh eight times as much. The double-sized bridge could be so weak that it would collapse under its own weight.

3. Sorcerer's Den

Height and weight

Let us suppose that there is no limit as to how tall a person could grow. Now imagine someone growing rapidly, becoming progressively taller and therefore heavier.

The question the reader is asked to consider is this: Would the person's weight increase for ever?

Height and weight. Solution

Yes and no. Our weight is governed by the gravitational attraction of the Earth. However, part of this force is counterbalanced by the centripetal force due to the rotation of the globe. This force is zero at the poles, increasing to a maximum at the equator. A person standing, for example, in Quito will have his centre of gravity move up as he grows, thereby increasing the centripetal force, while at the same time reducing the effect of gravity. Consequently, a point will come when the resultant weight will start to decrease. When the centre of gravity is about 22,000 miles (36,000 km) high, the person would be weightless and effectively in orbit. Needless to say, at one of the poles, the weight would keep on increasing, irrespective of height, ignoring other gravitational forces in the universe.

B–41.

♠ 10 4 2
♡ A Q 5 2
◊ A K 10 6 4 2
♣ —

♠ Q 9 5
♡ J 8 6 3
◊ J 7
♣ J 10 9 4

N
W E
S

♠ J 7
♡ 10 4
◊ Q 9 3
♣ A 8 7 5 3 2

♠ A K 8 6 3
♡ K 9 7
◊ 8 5
♣ K Q 6

You play 6 Spades, sitting South. West leads the ♣J. Can you make the contract?

P–41. Speed of sound

The speed of sound in air is about 740 miles per hour. Suppose that a police car is sounding its siren and is driving towards you at 60 miles per hour. At what speed is the sound of the siren approaching you?

B–41. Solution

```
            ♠ 10 4 2
            ♥ A Q 5 2
            ◊ A K 10 6 4 2
            ♣ —
♠ Q 9 5                      ♠ J 7
♥ J 8 6 3      N             ♥ 10 4
◊ J 7       W     E          ◊ Q 9 3
♣ J 10 9 4     S             ♣ A 8 7 5 3 2
            ♠ A K 8 6 3
            ♥ K 9 7
            ◊ 8 5
            ♣ K Q 6
```

You ruff the lead in dummy. What next? Suppose you draw two rounds of trumps, then play to set up the Diamonds. West will overruff the third round of Diamonds and, with no trumps left in the dummy, you will lose a Club trick. The same fate awaits if you cross to the ♥K and take a second Club ruff before playing the top two trumps. You have to lose a trump trick eventually, and it makes good sense to do this at a time when the opponents cannot cash a club. After ruffing the first trick, you should duck a round of trumps—playing a low trump from both hands. The defenders cannot cash a Club at that time because you still have a trump in dummy. Whatever they return, you will win, draw trumps, and set up the Diamonds with one ruff. You can then return to dummy with a Heart to discard your two remaining Clubs on the good Diamonds.

P–41. Solution

The speed of sound remains at 740 miles per hour; it does not get an extra 'push' by approaching you. The sound waves will be crowded closer together, however, resulting in a higher pitch, known as the Doppler effect.

B–42.

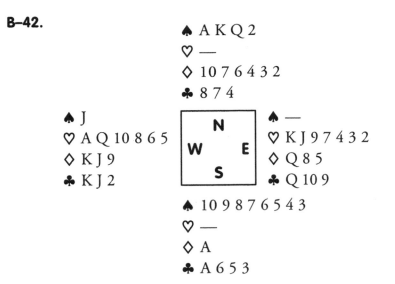

	♠ A K Q 2	
	♡ —	
	◊ 10 7 6 4 3 2	
	♣ 8 7 4	

♠ J ♠ —
♡ A Q 10 8 6 5 ♡ K J 9 7 4 3 2
◊ K J 9 ◊ Q 8 5
♣ K J 2 ♣ Q 10 9

♠ 10 9 8 7 6 5 4 3
♡ —
◊ A
♣ A 6 5 3

South plays in 6 Spades. West leads the ♠J. Can you make the contract?

P–42. Word affinity

All but one of the following have something in common. What is it, and which is the odd one out?

SOCK	SICK	BRICK	BUS	POCKET
FIELD	LINE	TIGHT	FORCE	LIFT

B–42. Solution

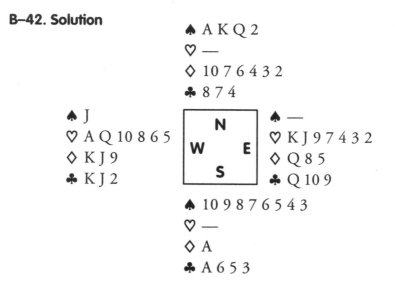

```
                    ♠ A K Q 2
                    ♡ —
                    ◊ 10 7 6 4 3 2
                    ♣ 8 7 4
  ♠ J                                    ♠ —
  ♡ A Q 10 8 6 5         N               ♡ K J 9 7 4 3 2
  ◊ K J 9            W         E          ◊ Q 8 5
  ♣ K J 2                S               ♣ Q 10 9
                    ♠ 10 9 8 7 6 5 4 3
                    ♡ —
                    ◊ A
                    ♣ A 6 5 3
```

To avoid two Club losers, you must set up dummy's Diamonds. You need three entries to dummy, two to ruff Diamonds, one to reach the established winners in the suit. If you win the first trick, you will employ one of the three entries at the wrong moment—while the Diamonds are blocked. You must therefore duck the first trick! Suppose West switches to a Club. You win with the Ace, cash the ◊A, and cross to dummy with a trump. You ruff a Diamond, return to dummy with a trump, and ruff the Diamonds good. A trump to dummy and you can claim. If instead West gives a ruff-and-discard at trick 2, you ruff in the South hand and again set up the Diamonds.

P–42. Solution

With the exception of SOCK all the words in the two rows can be prefixed by AIR. (The prefix for SOCK that most immediately comes to mind is WIND.)

B–43.

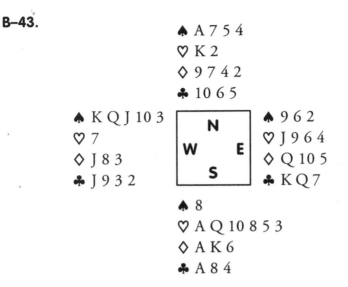

♠ A 7 5 4
♡ K 2
♢ 9 7 4 2
♣ 10 6 5

♠ K Q J 10 3
♡ 7
♢ J 8 3
♣ J 9 3 2

♠ 9 6 2
♡ J 9 6 4
♢ Q 10 5
♣ K Q 7

♠ 8
♡ A Q 10 8 5 3
♢ A K 6
♣ A 8 4

Sitting South, you arrive in 4 Hearts. West leads ♠K. What is your best line to guard against the four trumps in East's hand?

P–43. The parking dodge

After trying for weeks, Clive Gordon managed to get two tickets for *Sunset Boulevard* at the Adelphi Theatre on the Strand. Traffic was heavy, and he arrived at the theatre with only minutes to spare. He had no time nor the inclination to look for a garage. He parked the car at a meter which he did not even bother to feed, although it was already on excess.

He had no disabled badge and yet he knew he would not get a ticket. How did he manage it?

B–43. Solution

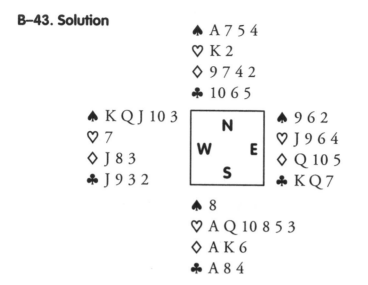

```
              ♠ A 7 5 4
              ♡ K 2
              ◊ 9 7 4 2
              ♣ 10 6 5

♠ K Q J 10 3         ♠ 9 6 2
♡ 7              N    ♡ J 9 6 4
◊ J 8 3      W       E ◊ Q 10 5
♣ J 9 3 2        S    ♣ K Q 7

              ♠ 8
              ♡ A Q 10 8 5 3
              ◊ A K 6
              ♣ A 8 4
```

To achieve a trump coup you will need to ruff two Spades to reduce your trumps to the same length as East's. At trick 2 you make the cost-nothing play of ruffing a Spade, reducing your trump length to five. You then play the Ace of trumps, followed by a trump to the King. If trumps break 3-2, you simply return to hand and draw the last trump. When, as here, East turns up with four trumps, you are conveniently in the dummy to take a second Spade ruff. All is now well. You cash your three top cards in the minors and pass the lead to the defenders. You are sure to score two tricks with your Q-10 of trumps.

P–43. Solution

He removed a parking ticket from another car and stuck it on his. On leaving the theatre he replaced it, if the offending car was still there. If not he discarded it. Not strictly cricket is it!

B–44.

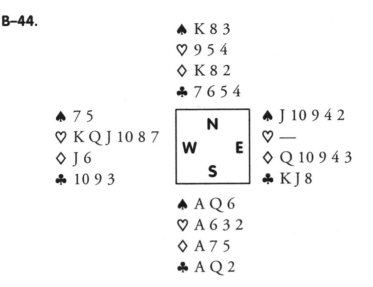

 ♠ K 8 3
 ♡ 9 5 4
 ◇ K 8 2
 ♣ 7 6 5 4

♠ 7 5 ♠ J 10 9 4 2
♡ K Q J 10 8 7 ♡ —
◇ J 6 ◇ Q 10 9 4 3
♣ 10 9 3 ♣ K J 8

 ♠ A Q 6
 ♡ A 6 3 2
 ◇ A 7 5
 ♣ A Q 2

You are South, trying to make 3 no trumps. West leads the ♡K, on which East discards the ♠2. Can you make your contract against best defence?

P–44. Bus timetable

A man drives along a main road on which a regular service of buses is in operation. He is driving at a constant speed. He notices that every 3 minutes he meets a bus and that every 6 minutes a bus overtakes him. How often does a bus leave the terminal station at one end of the route?

B–44. Solution

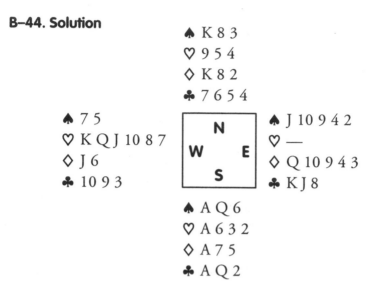

<pre>
 ♠ K 8 3
 ♡ 9 5 4
 ◇ K 8 2
 ♣ 7 6 5 4
 ♠ 7 5 ♠ J 10 9 4 2
 ♡ K Q J 10 8 7 N ♡ —
 ◇ J 6 W E ◇ Q 10 9 4 3
 ♣ 10 9 3 S ♣ K J 8
 ♠ A Q 6
 ♡ A 6 3 2
 ◇ A 7 5
 ♣ A Q 2
</pre>

You need three Club tricks to bring the total to nine, and must establish these without allowing West on lead. Suppose you cross to one of dummy's entries and lead a Club. East may contribute the Jack, aiming to create a Club entry to the West hand. You win with the Queen but can no longer make the contract. If you cash the ♣A East will throw the King on it. If instead you use dummy's remaining entry to lead towards the Ace (planning to duck if the King comes from East), you will have no entry to the thirteenth Club. The solution is to cash the ♣A from hand. It makes no difference which honour East unblocks. You then cross to dummy and lead towards the Queen, ducking if East plays an honour.

P–44. Solution

The buses are evenly spaced along the road in both directions. The man notices buses at a rate of 30 an hour. Because he is moving towards one 'stream' of buses and away from the other, he sees more buses in one direction than the other (20 to 10), but if he were stationary he would see 15 an hour travelling each way. The buses therefore leave the terminal at 4-minute intervals.

B–45.

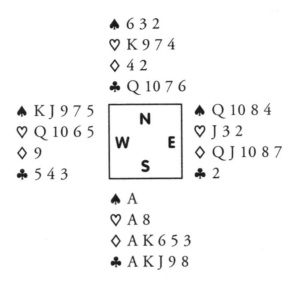

♠ 6 3 2
♡ K 9 7 4
◇ 4 2
♣ Q 10 7 6

♠ K J 9 7 5
♡ Q 10 6 5
◇ 9
♣ 5 4 3

♠ Q 10 8 4
♡ J 3 2
◇ Q J 10 8 7
♣ 2

♠ A
♡ A 8
◇ A K 6 5 3
♣ A K J 9 8

Sitting South, your contract is 6 Clubs. West leads a trump. Can you make your contract against best defence?

P–45. Insomnia

IBM executives held a sales conference at a hotel in Miami. Pete and Dave occupied adjoining rooms. After a strenuous day of presentations and partying, they went to their rooms. Despite being exhausted, Pete just could not get off to sleep. Eventually, at about two in the morning, he called the switchboard and asked to be put through to Dave's room. As soon as Dave picked up the phone, Pete replaced his and fell asleep.

Explain.

B–45. Solution

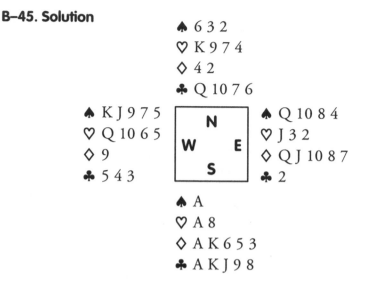

♠ 6 3 2
♡ K 9 7 4
♢ 4 2
♣ Q 10 7 6

♠ K J 9 7 5
♡ Q 10 6 5
♢ 9
♣ 5 4 3

♠ Q 10 8 4
♡ J 3 2
♢ Q J 10 8 7
♣ 2

♠ A
♡ A 8
♢ A K 6 5 3
♣ A K J 9 8

Suppose you win the trump lead and immediately cash the ◊A and ◊K. West will ruff the second Diamond honour and return a trump. You will then have only two trumps in dummy to deal with three losing Diamonds. One down. It's the same if you draw two rounds of trumps yourself, following with the top Diamonds. The solution is to cash only one top Diamond, then to lead a low Diamond. The defenders could win and lead back a trump. Declarer would have two high trumps in dummy with which to ruff his remaining two Diamond losers.

P–45. Solution

Pete was being kept awake by Dave's snoring.

B–46.

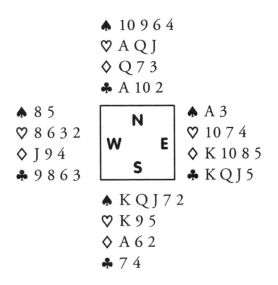

♠ 10 9 6 4
♡ A Q J
◊ Q 7 3
♣ A 10 2

♠ 8 5
♡ 8 6 3 2
◊ J 9 4
♣ 9 8 6 3

♠ A 3
♡ 10 7 4
◊ K 10 8 5
♣ K Q J 5

♠ K Q J 7 2
♡ K 9 5
◊ A 6 2
♣ 7 4

South arrived in 4 Spades, and West led a trump to his partner's Ace. Declarer allowed the ♣K switch to win, then won the ♣J continuation with dummy's Ace. Suppose you had been the declarer. How would you have played the hand on the assumption that the bidding sequence makes it likely that the ◊K is in East's hand?

P–46. The bird cage

A cage with a bird in it, perched on a swing, weighs 4 lbs. Is the weight of the cage less if the bird is flying about the cage instead of sitting on the swing?

Ignoring the fact that if left in an airtight box for long the bird would die, would the answer be different if an airtight box were substituted for the cage?

B–46. Solution

```
              ♠ 10 9 6 4
              ♡ A Q J
              ◊ Q 7 3
              ♣ A 10 2
♠ 85          ┌─────────┐        ♠ A 3
♡ 8 6 3 2     │    N    │        ♡ 10 7 4
◊ J 9 4       │ W     E │        ◊ K 10 8 5
♣ 9 8 6 3     │    S    │        ♣ K Q J 5
              └─────────┘
              ♠ K Q J 7 2
              ♡ K 9 5
              ◊ A 6 2
              ♣ 7 4
```

Cash three round of Hearts, eliminating that suit, then lead dummy's ♣10. East has to cover, and you throw one of your losing Diamonds. East has two losing options now. He could lead away from the ◊K or concede a ruff-and-discard by playing another Club. Ten tricks either way!

P–46. Solution

If the bird is in a completely airtight box, the weight of the box and the bird will be the same whether the bird is flying or perching. If the bird is flying, its weight is borne by the air pressure on its wings; but this pressure is then transmitted by the air to the floor of the box.

If the bird is flying in an open cage, part of the increase in pressure on the air is transmitted to the floor of the cage, but part is transmitted to the atmosphere outside the cage. Hence the cage with the bird will be lighter if the bird is flying.

B–47.

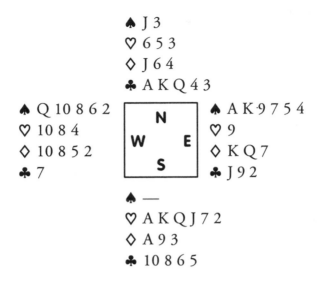

```
              ♠ J 3
              ♡ 6 5 3
              ◊ J 6 4
              ♣ A K Q 4 3

♠ Q 10 8 6 2                    ♠ A K 9 7 5 4
♡ 10 8 4          N             ♡ 9
◊ 10 8 5 2    W       E         ◊ K Q 7
♣ 7               S             ♣ J 9 2

              ♠ —
              ♡ A K Q J 7 2
              ◊ A 9 3
              ♣ 10 8 6 5
```

South is declarer in 6 Hearts. West leads ♣7. The contract seems on ice: 6 Hearts, 5 Clubs, 1 Diamond makes 12 tricks. Is it really that simple?

P–47. Sisters

Two look-alike girls sitting on a park bench are approached by a stranger. 'You must be twins,' he says.

The girls smile. 'We have the same parents and were born on the same day in the same year but, no, we're not twins.'

How come?

B–47. Solution

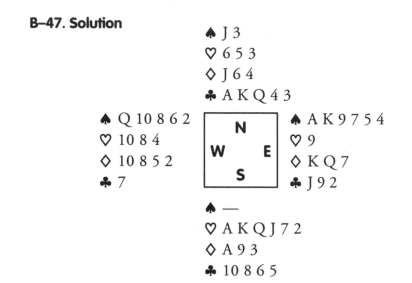

You win the Club lead with the Ace, and draw trumps in three rounds. The problem now is that the club suit is blocked. If you simply cash the three top Clubs and play a fourth Club, you will have to win in the South hand. There is no further entry to dummy. You should cross to dummy with a second top Club and lead a Spade, throwing a Club from the South hand. You can then win the return and score an easy 12 tricks.

P–47. Solution

They are two of a set of triplets or quadruplets, etc.

B–48.

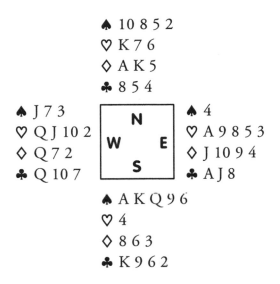

♠ 10 8 5 2
♡ K 7 6
◇ A K 5
♣ 8 5 4

♠ J 7 3
♡ Q J 10 2
◇ Q 7 2
♣ Q 10 7

♠ 4
♡ A 9 8 5 3
◇ J 10 9 4
♣ A J 8

♠ A K Q 9 6
♡ 4
◇ 8 6 3
♣ K 9 6 2

You are declarer in 4 Spades. West leads the ♡Q and continues with the ♡J, which you ruff. Can you make your contract against best defence?

P–48. The elevator stopped

A woman leaves her apartment, situated on the tenth floor of a high-rise building. She calls the elevator and begins to descend. The elevator comes to an abrupt stop between the fourth and third floors, and the light goes out. At that moment the woman's face turns ashen and she exclaims, 'Oh God, my husband is dying.'

Explain.

B–48. Solution

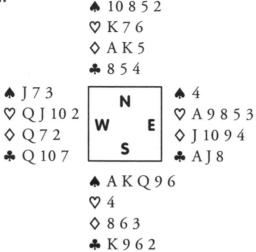

```
              ♠ 10 8 5 2
              ♡ K 7 6
              ◊ A K 5
              ♣ 8 5 4

♠ J 7 3                      ♠ 4
♡ Q J 10 2                   ♡ A 9 8 5 3
◊ Q 7 2                      ◊ J 10 9 4
♣ Q 10 7                     ♣ A J 8

              ♠ A K Q 9 6
              ♡ 4
              ◊ 8 6 3
              ♣ K 9 6 2
```

You need to find East with three Clubs to the Ace. It would be a mistake to cross to a Diamond to lead towards the ♣K. When the defenders took the first of their Club stoppers, they would knock out dummy's remaining high Diamond and then cash a Diamond when they won the second Club stopper. The first round of Clubs should be led from hand. East wins and plays a Diamond. You win in dummy, and play a Club towards the King. A third round will clear a long card in the suit. You can then win the Diamond in dummy, cross to hand with a Heart ruff, and throw a Diamond on the long Club. A Diamond ruff in dummy will be the 10th trick.

P–48. Solution

The woman's husband depends on a life support system connected to the electricity supply in their apartment on the tenth floor. What happened to the elevator made the woman realise the building was suffering a power failure.

B–49.

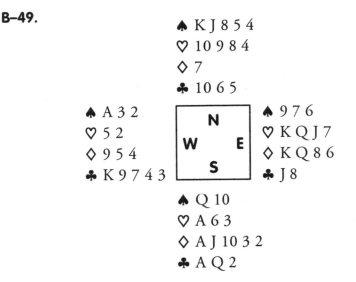

 ♠ K J 8 5 4
 ♡ 10 9 8 4
 ◇ 7
 ♣ 10 6 5

 ♠ A 3 2 ♠ 9 7 6
 ♡ 5 2 N ♡ K Q J 7
 ◇ 9 5 4 W E ◇ K Q 8 6
 ♣ K 9 7 4 3 S ♣ J 8

 ♠ Q 10
 ♡ A 6 3
 ◇ A J 10 3 2
 ♣ A Q 2

South plays in 3 no trumps. West leads the ♣4, and East plays the ♣J. If you can make your contract, you deserve a medal. Frances Thierry van Reeth did, in a deal from the Vivendi World Championship in Lille some years ago.

P–49. The heir

The king dies, and two men, the true heir and an impostor, both claim to be his long-lost son. Both fit the description of the rightful heir: about the right age, height, colouring and general appearance. Finally, one of the elders proposes a test to identify the true heir. One man agrees to the test while the other flatly refuses. The one who agreed is immediately sent on his way, and the one who refused is correctly identified as the rightful heir.

Why?

B–49. Solution

♠ K J 8 5 4
♥ 10 9 8 4
♦ 7
♣ 10 6 5

♠ A 3 2
♥ 5 2
♦ 9 5 4
♣ K 9 7 4 3

♠ 9 7 6
♥ K Q J 7
♦ K Q 8 6
♣ J 8

♠ Q 10
♥ A 6 3
♦ A J 10 3 2
♣ A Q 2

Can you imagine how van Reeth made the contract? Deceptively, he won the first trick with the ♣A, rather than the ♣Q. When he played the ♠Q, West ducked and East signalled with the ♠6 to show 3 cards in the suit. West took the second Space with the Ace and, placing his partner with the ♣Q, continued with ♣3. Imagine his surprise when dummy's 10 won the trick! Declarer had conjured an entry to dummy. He ran the Spades and was then able to establish a ninth trick in the Diamond suit.

P–49. Solution

The test was a blood test. The elder remembered that the true prince was a haemophiliac.

B–50.

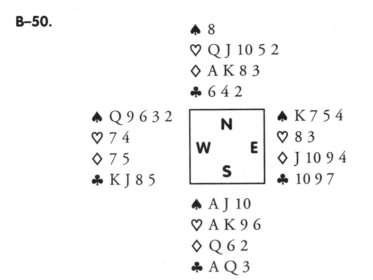

♠ 8
♥ Q J 10 5 2
♦ A K 8 3
♣ 6 4 2

♠ Q 9 6 3 2
♥ 7 4
♦ 7 5
♣ K J 8 5

♠ K 7 5 4
♥ 8 3
♦ J 10 9 4
♣ 10 9 7

♠ A J 10
♥ A K 9 6
♦ Q 6 2
♣ A Q 3

South bids 6 Hearts. West leads the ♥7. Can declarer make his contract?

P–50. Red or green

You are given four pieces of cardboard and told that each one is either red or green on one side, and that each one has either a circle or a square on the other side. They appear on the table as follows:

How many cards, and which ones, must you turn over in order to have sufficient information to answer the question: Does every red card have a square on its other side?

B–50. Solution

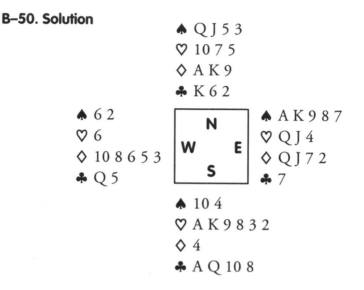

♠ Q J 5 3
♡ 10 7 5
◊ A K 9
♣ K 6 2

♠ 6 2
♡ 6
◊ 10 8 6 5 3
♣ Q 5

♠ A K 9 8 7
♡ Q J 4
◊ Q J 7 2
♣ 7

♠ 10 4
♡ A K 9 8 3 2
◊ 4
♣ A Q 10 8

Declarer drew trumps in two rounds and played the three top Diamonds. Had the suit broken 3–3, all would have been well. If West had shown up with four Diamonds, declarer would have crossed to the ♠A and ruffed a Spade. He would then return to his hand with a trump and ruff his last Spade. He could then end-play West with the fourth Diamond, throwing a Club. When East turned up with the fourth Diamond, declarer tried something different. He led a Spade to the Jack. West won with the Queen and was end-played. He had no Diamond to play, and a lead of either black suit would be into South's tenance.

P–50. Solution

Most people erroneously include No. 4 in their answer. But consider: No. 2 does not matter since the question is concerned only with red cards. If No. 1 has a circle, the answer to the question is NO. Similarly, if No. 3 is red the answer is NO. If No. 1 is a square, No. 3 is green, and No. 4 is either red or green, the answer is YES. Therefore the answer is: No. 1 and No. 3.

B–51.

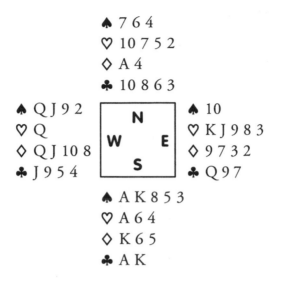

♠ 7 6 4
♡ 10 7 5 2
◊ A 4
♣ 10 8 6 3

♠ Q J 9 2
♡ Q
◊ Q J 10 8
♣ J 9 5 4

♠ 10
♡ K J 9 8 3
◊ 9 7 3 2
♣ Q 9 7

♠ A K 8 5 3
♡ A 6 4
◊ K 6 5
♣ A K

Sitting South, you are in 4 Spades. West leads the ◊Q. How would you play the hand?

P–51. The barber shop

After leaving work one evening, David looks in on a barber shop on his route home. The barber shop is a one-man business, and on that evening the proprietor is shaving a customer and has a long line of other customers waiting their turn.

'How long will you be?' David asks. The barber, after a little reflection, replies, 'Hour. Hour and a half.'

David thanks him and leaves.

A few days later, David checks out the barber shop again. This time the barber estimates he will be able to get to David in about 40 minutes. Once again, David thanks him and leaves.

The following day, the barber is just finishing up with the last customer. 'Give me 30 seconds,' he tells David. David thanks the barber, but instead of waiting leaves the shop.

Explain.

B–51. Solution

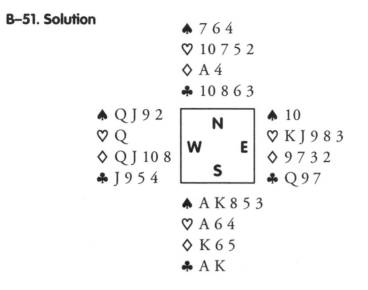

♠ 7 6 4
♡ 10 7 5 2
◇ A 4
♣ 10 8 6 3

♠ Q J 9 2
♡ Q
◇ Q J 10 8
♣ J 9 5 4

N W E S

♠ 10
♡ K J 9 8 3
◇ 9 7 3 2
♣ Q 9 7

♠ A K 8 5 3
♡ A 6 4
◇ K 6 5
♣ A K

Suppose you win the Diamond lead with the ace, and… you will go down! There are two certain Heart losers, so the main risk to the contract is that trumps will break 4-1 and you will also lose two trump tricks. You may be able to survive a bad trump break if you can take two ruffs in your hand with low trumps. To preserve entries to the dummy, you should win the Diamond lead with the King. You then cash the Ace and King of trumps, discovering the bad split. Cash the ♣A and ♣K, and cross to the ◇A. You then ruff a Club, ruff a Diamond to return to dummy, and ruff another Club. Perhaps surprisingly, this brings your total to 10 tricks: five side-suit winners, the trump Ace and King, one ruff in the dummy and two ruffs in hand.

P–51. Solution

David and the barber's wife are having an affair. They arrange their meetings for the end of the day, and David checks on the barber's workload to make sure he won't be home too soon.

B–52.

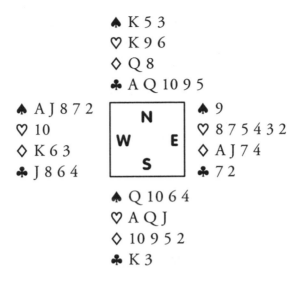

♠ K 5 3
♥ K 9 6
♦ Q 8
♣ A Q 10 9 5

♠ A J 8 7 2
♥ 10
♦ K 6 3
♣ J 8 6 4

♠ 9
♥ 8 7 5 4 3 2
♦ A J 7 4
♣ 7 2

♠ Q 10 6 4
♥ A Q J
♦ 10 9 5 2
♣ K 3

South plays 3 no trumps. West leads the ♠7. Can this contract be made against best defence?

P–52. The car crash

Harry Jones was driving home in his car with his son Robert in the passenger seat. The car was involved in a head-on collision with a truck, killing Harry outright. Robert was seriously injured and taken to hospital by ambulance. In the hospital operating theatre, his would-be surgeon took one look at Robert and said, 'I'm sorry, but I can't operate on this patient—he's my son.'

What is the explanation?

B–52. Solution

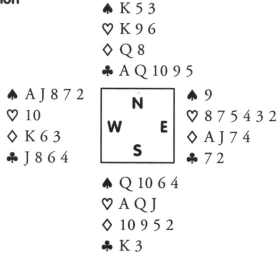

♠ K 5 3
♡ K 9 6
◇ Q 8
♣ A Q 10 9 5

♠ A J 8 7 2 ♠ 9
♡ 10 ♡ 8 7 5 4 3 2
◇ K 6 3 ◇ A J 7 4
♣ J 8 6 4 ♣ 7 2

♠ Q 10 6 4
♡ A Q J
◇ 10 9 5 2
♣ K 3

South was the brilliant young American, Mike Lawrence, one of the Dallas Aces who recovered the world title for the USA in 1970. In 1966, when this hand was played at the Summerton Club in San Francisco, he was less well known. Winning the first trick with ♠10, he immediately returned a Spade. West ducked, perforce, as otherwise declarer has nine tricks. Now came the second key play, a *Diamond* from dummy. Three Hearts, three Clubs, two Spades and the Diamond Lawrence eventually established were enough tricks to fulfil the contract. Clearly if declarer had tried to establish the Clubs the defence would have had five tricks: one Spade, one Club and three Diamonds.

P–52. Solution

Shame on you, you male chauvinist! The surgeon was Mrs—er, Ms—Jones, Robert's mother.

B–53.

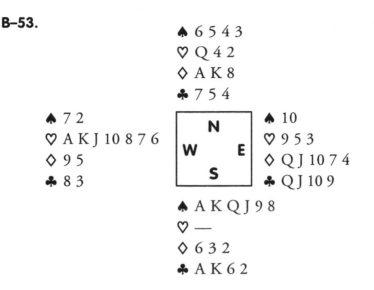

 ♠ 6 5 4 3
 ♡ Q 4 2
 ◊ A K 8
 ♣ 7 5 4

♠ 7 2 ♠ 10
♡ A K J 10 8 7 6 ♡ 9 5 3
◊ 9 5 N ◊ Q J 10 7 4
♣ 8 3 W E ♣ Q J 10 9
 S

 ♠ A K Q J 9 8
 ♡ —
 ◊ 6 3 2
 ♣ A K 6 2

Sitting South, you are in 6 Spades. West leads the ♡K. How should you continue?

P–53. The unfaithful wife

Chuck, a best-selling author of romantic fiction, had suspected for some time that his wife Eva was unfaithful, though he had no proof.

One afternoon, while Chuck was working on his latest bodice-ripper, Eva mentioned that she intended to go to the movies and would be out for a few hours. As Eva went to the door, Chuck looked at her pensively, then resumed his work.

Three hours later, Eva returned, took her coat off, and asked Chuck whether he wanted some coffee. When she returned from the kitchen, Chuck asked her to sit down as he wanted to talk to her.

'Eva,' he said, 'I want a divorce.'

What had proved to him that she was having an affair?

B–53. Solution

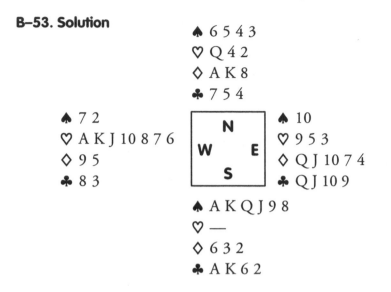

```
              ♠ 6 5 4 3
              ♡ Q 4 2
              ◇ A K 8
              ♣ 7 5 4
♠ 7 2                        ♠ 10
♡ A K J 10 8 7 6     N       ♡ 9 5 3
◇ 9 5            W       E   ◇ Q J 10 7 4
♣ 8 3               S        ♣ Q J 10 9
              ♠ A K Q J 9 8
              ♡ —
              ◇ 6 3 2
              ♣ A K 6 2
```

This hand arose in a round of Crockfords Cup, the teams' championship of England. Both declarers arrived in 6 Spades after similar bidding sequences. The first three tricks were the same in both rooms. Then the first declarer cashed ♣A, ◇A and ♣K. Finally he resigned himself to a 3–3 Club break when he played a third Club. Minus 50 was his just reward.

The second declarer, Harrison-Gray, played a Diamond to ◇A, ruffed a low Heart, cashed his two top Clubs, and played a Diamond to ◇K. Now ♡Q, on which he discarded his last Diamond, forced West to concede a ruff and discard, enabling declarer to make the remainder of the tricks on a cross-ruff.

P–53. Solution

On Eva's way out, Chuck had noticed a ladder in her left stocking. When she went to the kitchen for coffee, he noticed that the run was on her right leg.

B–54.

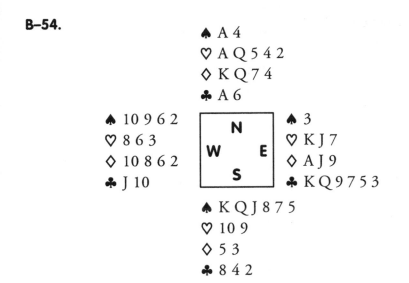

♠ A 4
♡ A Q 5 4 2
♢ K Q 7 4
♣ A 6

♠ 10 9 6 2
♡ 8 6 3
♢ 10 8 6 2
♣ J 10

♠ 3
♡ K J 7
♢ A J 9
♣ K Q 9 7 5 3

♠ K Q J 8 7 5
♡ 10 9
♢ 5 3
♣ 8 4 2

Contract is 4 Spades by South. West leads the ♣J. How should declarer plan the play?

P–54. Boy and girl

A boy and a girl are talking.

'I'm a boy,' says the one with black hair.

'I'm a girl,' says the one with red hair.

If at least one of them is lying, which is which?

B–54. Solution

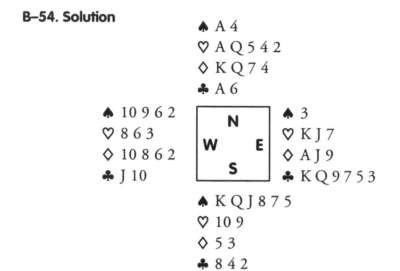

```
                    ♠ A 4
                    ♡ A Q 5 4 2
                    ◊ K Q 7 4
                    ♣ A 6
    ♠ 10 9 6 2          N          ♠ 3
    ♡ 8 6 3        W         E     ♡ K J 7
    ◊ 10 8 6 2         S          ◊ A J 9
    ♣ J 10                         ♣ K Q 9 7 5 3
                    ♠ K Q J 8 7 5
                    ♡ 10 9
                    ◊ 5 3
                    ♣ 8 4 2
```

Strangely, once the defence is permitted to hold the first trick, the contract is impregnable. Yet unless South ducks ♣J he will surely be defeated. Suppose, first, that East overtakes and plays a trump. Dummy wins and plays ◊K forcing East's ◊A—if East refuses the first round, ◊Q follows. ♣A is knocked out, and now all South has to do is to ruff the third round of Diamonds and run all his trumps, eventually throwing East in with a Club to concede the last two Heart tricks.

If Clubs are continued by the defence at trick two, ◊K again opens up the communications. If East plays anything but a trump, having won ◊A, declarer can pick up his Club ruff without losing a trump trick to West.

P–54. Solution

The boy has red hair, the girl black hair. There are four possible combinations: true–true, true–false, false–true, and false–false. It is not the first, since we are told that at least one statement is false. Nor is it the second or third because, in each case, if one lied, then the other could not have been telling the truth. Therefore it is the fourth: both lied.

B–55.

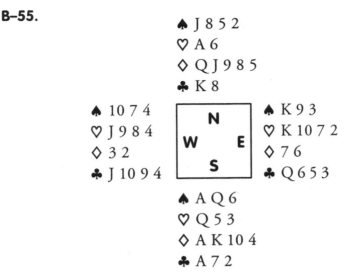

♠ J 8 5 2
♡ A 6
◇ Q J 9 8 5
♣ K 8

♠ 10 7 4
♡ J 9 8 4
◇ 3 2
♣ J 10 9 4

♠ K 9 3
♡ K 10 7 2
◇ 7 6
♣ Q 6 5 3

♠ A Q 6
♡ Q 5 3
◇ A K 10 4
♣ A 7 2

South plays 6 Diamonds. West leads the ♣J. Can this contract be made?

P–55. The antique candelabrum

The scene is a famous antique dealer's in London. A Rolls-Royce pulls up, and a liveried chauffeur opens the door to a distinguished-looking elderly man who enters the shop. He points at a seventeenth-century candelabrum in the window, examines it closely, and then engages in an animated dialogue with the dealer. Eventually, he writes a cheque for £5,000 and departs with the candelabrum.

Shortly thereafter, the dealer makes a number of telephone calls before closing his store. Two days later, he receives a call which clearly pleases him.

In the mean time, the distinguished-looking man has carefully wrapped the candelabrum he bought. A younger man, Robert, arrives at his suite at the Ritz, takes the wrapped candelabrum by taxi to the same antique dealer from whom the older man bought it. The dealer pays him £9,000 in cash for the candelabrum.

What happened?

B–55. Solution

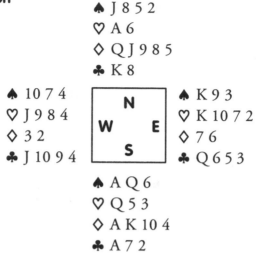

♠ J 8 5 2
♡ A 6
◊ Q J 9 8 5
♣ K 8

♠ 10 7 4 ♠ K 9 3
♡ J 9 8 4 ♡ K 10 7 2
◊ 3 2 ◊ 7 6
♣ J 10 9 4 ♣ Q 6 5 3

♠ A Q 6
♡ Q 5 3
◊ A K 10 4
♣ A 7 2

South must play an elimination and throw-in play, unless East turns up with ♠K x or ♠K alone. The Clubs are eliminated after drawing trumps, and the Spade finesse is followed by ♠A and a small Spade. East must now lead from his ♡K or concede a ruff and discard.

P–55. Solution

The elderly man had mentioned to the dealer that the candelabrum he bought was one of a rare pair that together was worth much more than twice the value of the one. He made it clear that he would pay handsomely if the dealer would locate the twin.

Not realising that the elderly man was a confidence trickster, the dealer then called around some of his friends in the trade until he was tipped off about a collector who was offering to sell a candelabrum just like the one the dealer had sold to the elderly man. Triumphantly, the dealer tracked down this 'second' candelabrum to Robert, agreed to buy it from him for £9,000, expecting to make a killing when he sold it on to the elderly man as the second part of the complete pair. Needless to say, the elderly man disappeared without trace but *with* £4,000 profit!

B–56.

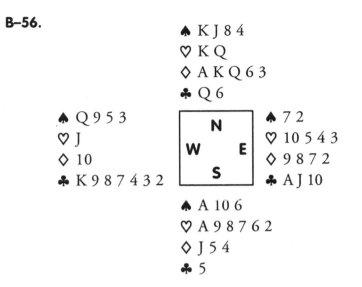

The contract is 6 Hearts. West leads the ♣9, won by Easts's ♣A. The ♣J is continued and ruffed by South. On dummy's top Hearts, West follows with the Jack and then discards a Club on the next round. South plays a Diamond to his Jack and a second Diamond, on which West shows out. How should South continue?

P–56. The painting

A man, looking at a painting, says to himself: 'Brothers and sisters have I none, but that man's father is my father's son.'

Who is the subject of the painting?

B–56. Solution

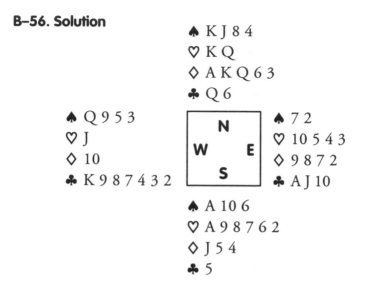

♠ K J 8 4
♥ K Q
♦ A K Q 6 3
♣ Q 6

♠ Q 9 5 3
♥ J
♦ 10
♣ K 9 8 7 4 3 2

♠ 7 2
♥ 10 5 4 3
♦ 9 8 7 2
♣ A J 10

♠ A 10 6
♥ A 9 8 7 6 2
♦ J 5 4
♣ 5

South was a former world champion, although his performance on this hand would never have given any indication of the fact! Having ruffed the second Club, he tabled his cards and said, 'Well, has anyone got four Hearts?' East claimed this privilege, so there was nothing for it but to concede one down.

After the trump distribution has been discovered, declarer should play four rounds of Diamonds, ruffing the fourth round in hand. Then he cashes ♠A and leads a Spade to dummy's ♠J. When this card holds the rest is plain sailing. Dummy plays ♦Q, and East can either surrender immediately or prolong the agony for one more round.

P–56. Solution

The man's own son.

B–57.

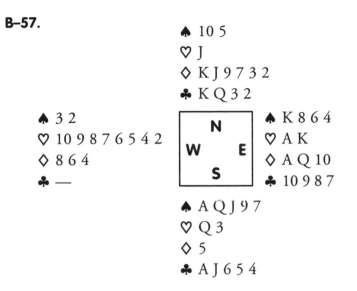

♠ 10 5
♡ J
◊ K J 9 7 3 2
♣ K Q 3 2

♠ 3 2
♡ 10 9 8 7 6 5 4 2
◊ 8 6 4
♣ —

♠ K 8 6 4
♡ A K
◊ A Q 10
♣ 10 9 8 7

♠ A Q J 9 7
♡ Q 3
◊ 5
♣ A J 6 5 4

West leads the ♡10 against South's contract of 5 Clubs. East wins with the ♡K, and switches to the ♣10, West discarding a small Heart. How should South continue?

P–57. How many children?

Each son in the Hubbard family has just as many brothers as sisters, but each daughter has twice as many brothers as sisters.

How many boys and girls are there in the family?

B–57. Solution

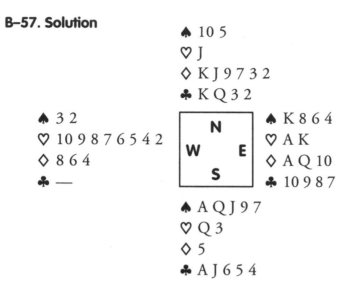

```
                    ♠ 10 5
                    ♡ J
                    ◇ K J 9 7 3 2
                    ♣ K Q 3 2
♠ 3 2                              ♠ K 8 6 4
♡ 10 9 8 7 6 5 4 2      N          ♡ A K
◇ 8 6 4            W        E      ◇ A Q 10
♣ —                    S          ♣ 10 9 8 7
                    ♠ A Q J 9 7
                    ♡ Q 3
                    ◇ 5
                    ♣ A J 6 5 4
```

The star of this hand was the fine pairs player Martin Hoffman. Playing in a multiple team event in 1970, he made one slightly different play to his rivals who had bid to game in Clubs. He won the Club switch in dummy and played ♠10. The other declarers also led ♠10 at trick three, and when it held continued with a second Spade finesse. ♠A revealed the 4–2 break, and a Spade was ruffed in dummy. Dummy now exited with a Diamond, won by East, who played a second round of trumps. Declarer had to win in dummy to avoid establishing a high trump for East. But now the problem of getting to hand, ruffing a Heart in dummy, and returning to hand to draw the trumps and enjoy the thirteenth Spade proved insurmountable. Each declarer had to admit defeat.

Martin Hoffman's solution? He overtook ♠10 with ♠J, ruffed ♡Q, and took a second Spade finesse. Now, after a Spade ruff and top Club from dummy, he was able to exit from dummy with a Diamond and without waiting for East's next card he claimed the remainder of the tricks.

P–57. Solution

Four boys and three girls.

B–58.

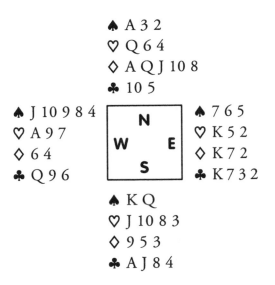

```
              ♠ A 3 2
              ♡ Q 6 4
              ◇ A Q J 10 8
              ♣ 10 5
♠ J 10 9 8 4                    ♠ 7 6 5
♡ A 9 7          N              ♡ K 5 2
◇ 6 4        W       E          ◇ K 7 2
♣ Q 9 6          S              ♣ K 7 3 2
              ♠ K Q
              ♡ J 10 8 3
              ◇ 9 5 3
              ♣ A J 8 4
```

West leads the ♠J against South's contract of 3 no trumps. How should declarer proceed?

P–58. Two bars of iron

Two bars of iron lie on a table. They look identical, but one of them is magnetized (with a pole at each end), the other is not.

How can you discover which bar is magnetized if you are only allowed to shift them on the table, without raising them, and without the help of any other object or instrument?

B-58. Solution

```
              ♠ A 3 2
              ♡ Q 6 4
              ◊ A Q J 10 8
              ♣ 10 5
♠ J 10 9 8 7   ┌─────────┐   ♠ 7 6 5 3
♡ A 9 7        │    N    │   ♡ K 5 2
◊ 6 4          │ W     E │   ◊ K 7 2
♣ Q 9 6        │    S    │   ♣ K 7 3 2
              └─────────┘
              ♠ K Q
              ♡ J 10 8 3
              ◊ 9 5 3
              ♣ A J 8 4
```

Louis Ström, one of Norway's leading stars, earned his team a game swing when this hand occurred in the 1964 Scandinavian Championships. His counterpart in the other room, also in 3 no trumps, finessed a Diamond at trick two. East continued with a second Spade, and when South now turned his attention to Hearts it was too late to prevent East clearing the Spades. Subsequently West regained the lead and cashed his Spade winners to set the contract by one trick.

Ström, readily appreciating the dangers of playing a Diamond too early, led a small heart to the ♡Q at trick two. East won and persevered with the Spades (nothing else is better). Now ♡J forced West's ♡A, and Ström was able to return to his own hand and take the Diamond finesse, secure in the knowledge that his contract could not fail as long as West had started with at least four Spades.

P-59. Solution

Take either bar and push one end against the middle of the other bar, forming a T. If the magnetized bar is the top of the T, there is no pull on the other bar.

B–59.

♠ A K 4
♡ 8 7 6 5
◊ K J
♣ Q 8 7 6

♠ 2
♡ K 10 9
◊ 8 6 5 4 3
♣ A K 10 2

♠ 8 6 3
♡ 3
◊ A Q 9 7 2
♣ J 9 5 4

♠ Q J 10 9 7 5
♡ A Q J 4 2
◊ 10
♣ 3

West leads the ♣K against South's contract of 4 Hearts, and then switches to the ♠2. What stratagem should South adopt to avert the impending ruff?

P–59. Cocktail

Four toothpicks and a penny are arranged as shown, to represent a cherry in an old-fashioned glass. Move two toothpicks and get the cherry outside of the glass. The glass may have any position at the end, but the cherry cannot be moved.

B–59. Solution

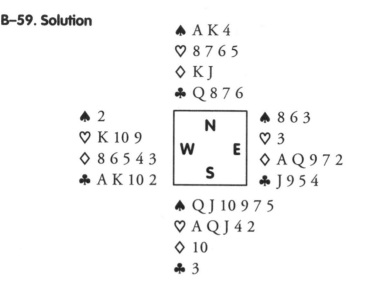

♠ A K 4
♡ 8 7 6 5
◇ K J
♣ Q 8 7 6

♠ 2
♡ K 10 9
◇ 8 6 5 4 3
♣ A K 10 2

♠ 8 6 3
♡ 3
◇ A Q 9 7 2
♣ J 9 5 4

♠ Q J 10 9 7 5
♡ A Q J 4 2
◇ 10
♣ 3

Declarer should win the second trick in dummy with ♠A and play ♣Q, throwing ◇10 from his own hand. It is obvious that West's South's ♠2 is a singleton; therefore this is the moment to employ the Scissors Coup—and cut the enemy communications. There is now no defence. If declarer fails to see the danger he will surely be defeated, for West, when in with ♡K, will switch to a Diamond, and East will then return a Spade for the setting trick.

P–59. Solution

You can do it by moving only two toothpicks. Slide the horizontal one over half a length, then bring down one of the vertical toothpicks to complete the upside-down glass.

B–60.

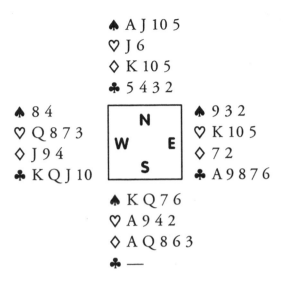

♠ A J 10 5
♡ J 6
◇ K 10 5
♣ 5 4 3 2

♠ 8 4
♡ Q 8 7 3
◇ J 9 4
♣ K Q J 10

♠ 9 3 2
♡ K 10 5
◇ 7 2
♣ A 9 8 7 6

♠ K Q 7 6
♡ A 9 4 2
◇ A Q 8 6 3
♣ —

South plays in 7 Spades. West leads the ♣K. Can you make your contract against best defence?

P–60. Death in the car

A man was shot to death while in his car. There were no powder marks on his clothing, which indicated that the gunman was outside the car. However, all the windows were up and the doors locked. After a close inspection was made, the only bullet-holes discovered were on the man's body.

How was he murdered?

B–60. Solution

♠ A J 10 5
♡ J 6
◊ K 10 5
♣ 5 4 3 2

♠ 8 4
♡ Q 8 7 3
◊ J 9 4
♣ K Q J 10

♠ 9 3 2
♡ K 10 5
◊ 7 2
♣ A 9 8 7 6

♠ K Q 7 6
♡ A 9 4 2
◊ A Q 8 6 3
♣ —

Declarer must appreciate two things. First he will have to score three ruffs in his own hand, which, together with dummy's four Spades, ♡A and five Diamond tricks, will bring his total to thirteen. Secondly, in order to achieve this, he will require three entries to dummy: two to ruff Clubs and one to draw trumps. As there will be only one trump entry, he will need *two* additional Diamond entries, which entails the assumption that West holds ◊J.

The opening lead is ruffed and a Diamond played to dummy's ◊10. A Club ruff, ◊K and a third Club ruff leaves only the mopping-up operation of drawing trumps and discarding three Heart losers from his own hand.

P–60. Solution

The victim was in a convertible. He was shot when the top was down.

4. Witches' Reward

The time machine

Most readers will have heard of the International Date Line (IDL), established as an irregular line, drawn by convention through the Pacific Ocean, substantially along the 180th meridian. IDL marks the place where the date changes.

Crossing the line from west to east, travellers gain a day and, conversely, lose a day travelling east to west. Jules Verne's novel *Around the World in 80 Days* was based on this phenomenon.

The position of the IDL has been arbitrarily designated, and is partly curved to accommodate eastern Siberia, then bulges westward again in order to avoid crossing land.

Let us now assume that a successor of the Concorde can take its passengers around the equator, circling the globe in six hours. Flying east to west it will cross the IDL four times in 24 hours and consequently lose four days. Starting, say, on the 18th of March it will land on the 14th of March. Continuing the journey the passengers will go back into history, eventually reliving the birth of Christ. Travelling east to west they will travel into the future, giving them a decisive advantage in the lottery on their return.

Is there something wrong with this reasoning?

The time machine. Solution

Yes, there certainly is. First, let us distinguish between natural time and an arbitrary time zone. A time zone is an area within which everyone has agreed to use the same time. However, every point on the Earth's surface has its own natural time. As one travels east, the natural time is farther ahead, one hour for every 15 degrees of longitude.

Let us suppose that the aircraft travels eastwards around the world so fast that it would complete the journey in one second, and it started from a point just to the east of the International Date Line. As it travelled it would encounter a natural time which was progressively further ahead.

When it arrived at a point just to the west of the IDL, the time would be 24 hours ahead. This extra day is then lost as the date line is crossed. The final time is then exactly one second after the start.

One cannot, therefore, travel into the past or future by using the International Date Line.

B–61.

♠ Q J 5 3
♡ 10 7 5
◇ A K 9
♣ K 6 2

♠6 led

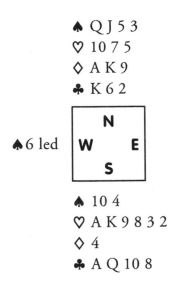

♠ 10 4
♡ A K 9 8 3 2
◇ 4
♣ A Q 10 8

Only the North and South hands are shown in this problem as all four hands would make the solution too obvious. West leads the ♠6 against South's contract of 5 Hearts. East wins with the King, cashes the ♠A, on which West follows with the ♠2, and then switches to the ♣7. How should South proceed?

P–61. Changing the odds

In a distant kingdom lived a king who had a beautiful daughter. She fell in love with and wanted to marry a humble peasant boy. The king had no intention of consenting to the marriage, and suggested that the decision be left to chance. The castle forecourt was covered with white and black pebbles. The king claimed to have picked up one of each colour, and put them into his hat. The suitor had to pick one pebble from the hat. A white pebble meant that he could marry the king's daughter; a black that he was never to see her again. The boy was poor but not stupid. He noticed that by sleight of hand the king had put two black pebbles into the hat.

How did the suitor resolve his predicament without calling the king a cheat?

B–61. Solution

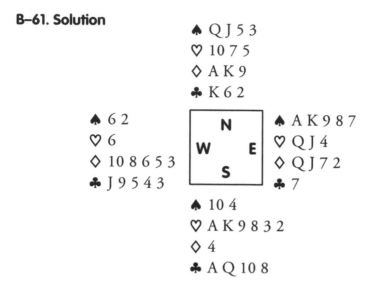

```
            ♠ Q J 5 3
            ♡ 10 7 5
            ◇ A K 9
            ♣ K 6 2
♠ 6 2          N          ♠ A K 9 8 7
♡ 6      W         E      ♡ Q J 4
◇ 10 8 6 5 3             ◇ Q J 7 2
♣ J 9 5 4 3     S        ♣ 7
            ♠ 10 4
            ♡ A K 9 8 3 2
            ◇ 4
            ♣ A Q 10 8
```

Declarer should direct his attention to this question: why did East, who is presumably marked with five Spades, not continue with a third Spade? If West has any heart honour, this would spell instant defeat. The conclusion that South should reach is that East must hold both ♡Q and ♡J, and is fearful of exposing the position. Thus declarer should win the Club switch in dummy and play ♡10—letting it run if East fails to cover.

P–61. Solution

The boy picked a pebble out of the hat and, before they had a chance to examine it, dropped it, apparently accidentally, where it was lost among the pebbles on the ground. He then pointed out to the king that the colour of the dropped pebble could be ascertained by checking the colour of the one remaining in the hat.

B–62.

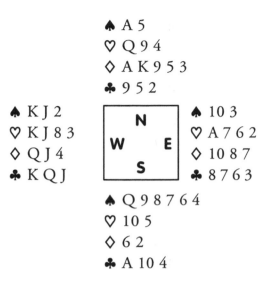

 ♠ A 5
 ♡ Q 9 4
 ◊ A K 9 5 3
 ♣ 9 5 2

♠ K J 2 ♠ 10 3
♡ K J 8 3 ♡ A 7 6 2
◊ Q J 4 ◊ 10 8 7
♣ K Q J ♣ 8 7 6 3

 ♠ Q 9 8 7 6 4
 ♡ 10 5
 ◊ 6 2
 ♣ A 10 4

West leads the ♣K against South's contract of 2 Spades. How should declarer plan the play?

P–62. Presidents

'Here is an odd item, Professor Flugel,' said Tom, looking up from his newspaper. 'It says here that three of the first five presidents of the United States died on the 4th of July. I wonder what the odds are against a coincidence like that.'

'I'm not sure,' replied the professor, 'but I'm willing to give 10 to 1 odds I can name one of the three who died on that date.'

Assuming that the professor had no prior knowledge of the dates on which any of the presidents died, was he justified in offering such odds?

B–62. Solution

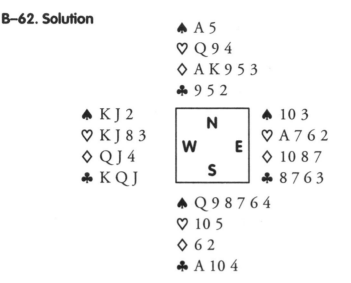

♠ A 5
♥ Q 9 4
♦ A K 9 5 3
♣ 9 5 2

♠ K J 2
♥ K J 8 3
♦ Q J 4
♣ K Q J

♠ 10 3
♥ A 7 6 2
♦ 10 8 7
♣ 8 7 6 3

♠ Q 9 8 7 6 4
♥ 10 5
♦ 6 2
♣ A 10 4

Declarer must appreciate that his task lies in avoiding the loss of two Clubs, two Hearts and two Spades. He wins ♣A and plays three rounds of Diamonds, ruffing the third round. ♠Q follows, which forces West to cover. Now a Diamond from dummy gives East a choice of plays: to ruff or discard. In either case, South disposes of a Club loser. If East ruffs, South will subsequently lose two Hearts, one Club and one Spade. If East discards West must ruff, and the same losers will be lost when South crashes the master Spades together. If South fails to play precisely ♠Q at trick five, the contract will be lost since West must make two Spade tricks while East can kill the Diamond lead from dummy.

P–62. Solution

If the fifth president were not among those who died on that date, then the newspaper item would almost certainly have made the more impressive statement: 'Three of the first four presidents died on the 4th of July.' Therefore, Professor Flugel was reasonably confident that the fifth president, James Monroe, died on that date.

B–63.

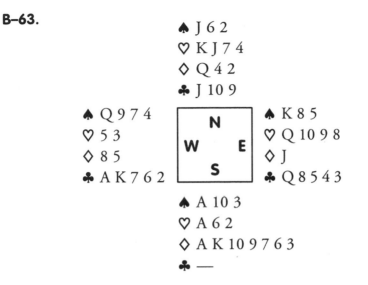

♠ J 6 2
♥ K J 7 4
♦ Q 4 2
♣ J 10 9

♠ Q 9 7 4
♥ 5 3
♦ 8 5
♣ A K 7 6 2

♠ K 8 5
♥ Q 10 9 8
♦ J
♣ Q 8 5 4 3

♠ A 10 3
♥ A 6 2
♦ A K 10 9 7 6 3
♣ —

West leads the ♣K against South's contract of 5 Diamonds. Assuming that trumps break 2–1, how should declarer play?

P–63. The joker

A friend offers you the following wager. He takes three playing cards from a new pack—one joker and two aces—then deals them out face-down in front of you. He then asks you to remove one card from the group of three, keeping it face-down so that neither of you can see it.

The object of the game is for you to try to pick the joker. If you succeed, he will pay you £1; if you fail you lose £1. The card you picked was at random because you didn't know in which order your friend dealt them out. But he did; he knows exactly which card is which, and turns over one of the two cards left on the table, showing it to be an Ace.

'Now there are two cards left,' your friend says. 'One on the table and one in your hand. One is another Ace; the other is the joker'.

What are the odds of the card in your hand being the joker?

B–63. Solution

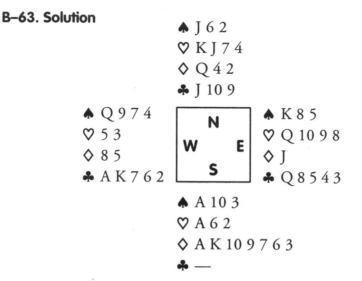

Declarer should ruff the opening lead with ◇6, cash the ◇A, and enter dummy with the ◇Q—still retaining the ◇3 in his own hand. A second Club is ruffed high and followed by ♡AK. Dummy's last Club is led, and South discards his losing Heart. Regardless of the distribution, it is now impossible for the defence to avoid establishing either a Heart or a second Spade trick for declarer, or concede a ruff and discard.

P–63. Solution

When you remove one card from the group of three, the probability that the joker will be your card is 1/3, and the probability that it will be one of the two left on the table is 2/3. However, since it is certain that one of the cards left on the table is an Ace, the odds are not altered by your friend turning the other Ace over. Which means that the odds of the card you removed being a joker are 1/3 and not 1/2 as one might assume.

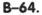

B–64.

	♠ 5 2	
	♡ A J 10 6 5	
	◊ 7 5 3	
	♣ A 9 4	
♠ Q 10 3		♠ J 9 8 7
♡ Q 3		♡ K 9 8 7
◊ Q J 8 2		◊ 10 9
♣ Q 6 3 2		♣ J 10 5
	♠ A K 6 4	
	♡ 4 2	
	◊ A K 6 4	
	♣ K 8 7	

West leads the ◊2 against South's contract of 3 no trumps. East plays the ◊9. How should South plan the play?

P–64. Burglars

Arthur lives with his parents in Chicago. Last week, while his parents were out, Arthur's next-door neighbour Sophie came round to spend the evening. At one point, she popped out to buy some cigarettes. Just then, two men burst into the apartment and, ignoring Arthur, took the TV set, the stereo and a computer.

Arthur had never seen the men before, and they had no legal right to remove the equipment, yet he did nothing to stop them. In fact, he didn't even act surprised by their behaviour. Why not?

B–64. Solution

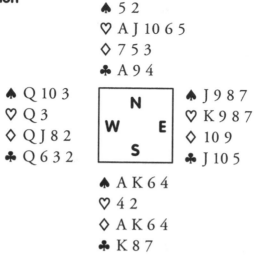

♠ 5 2
♡ A J 10 6 5
◇ 7 5 3
♣ A 9 4

♠ Q 10 3
♡ Q 3
◇ Q J 8 2
♣ Q 6 3 2

♠ J 9 8 7
♡ K 9 8 7
◇ 10 9
♣ J 10 5

♠ A K 6 4
♡ 4 2
◇ A K 6 4
♣ K 8 7

It is almost certain that West has led from a four-card Diamond suit, so declarer should win the first trick and immediately direct his mind to the play of the Heart suit. His problem is to establish three tricks in the suit and be able to enjoy them. If the Hearts are 3–3 any reasonable method will suffice, but if they break 4–2 South's approach will have to be the correct one. A Heart should be led towards the dummy, and no matter what Heart West plays dummy must play low. On regaining the lead declarer plays a second Heart towards dummy, this time going up with ♡A. When both opponents follow and one honour card has appeared the rest is simple.

Note the result if South makes the mistake of running ♡10 at trick two. East, if he is wide awake, will duck, and now there is no way in which declarer can both establish and enjoy his third Heart trick. Alternatively, West may go in with ♡Q on the first round, but declarer must resist the temptation to play dummy's ♡A.

P–64. Solution

Arthur is ten months old.

B–65.

♠ K 5 3 2
♡ 10 7 4
◊ A Q 7
♣ 6 4 2

♠ A Q 7 6
♡ Q 2
◊ 8 6 4 3 2
♣ 9 3

♠ J 10 9 8 4
♡ 6
◊ 10 9 5
♣ A K Q J

♠ —
♡ A K J 9 8 5 3
◊ K J
♣ 10 8 7 5

South plays in 4 Hearts. West leads the ♣9. East takes his three Club winners. Which card should West discard on the third Club to defeat the contract?

P–65. Gold card

This puzzle was a favourite of Wild West card-sharps, who won thousands of dollars from the unsuspecting gold prospectors. In a saloon, the gambler would gather a crowd and place three cards into a hat. These cards were coloured (1) gold on one side, gold on reverse, (2) silver on one side, silver on reverse, and (3) gold on one side, silver on reverse.

The gambler drew a card from the hat and placed it on the table with the gold side up. Then he said: 'The reverse side is either gold or silver as the card cannot be the silver/silver card. Therefore it is either the gold/silver or the gold/gold card—an even chance! I will bet even money one dollar that the reverse wide is gold.'

Is this a fair bet?

B–65. Solution

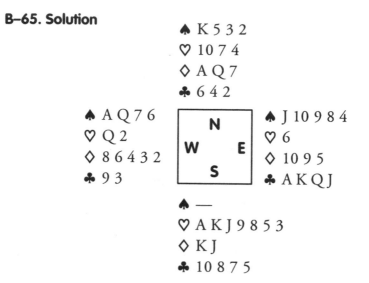

♠ K 5 3 2
♥ 10 7 4
♦ A Q 7
♣ 6 4 2

♠ A Q 7 6
♥ Q 2
♦ 8 6 4 3 2
♣ 9 3

♠ J 10 9 8 4
♥ 6
♦ 10 9 5
♣ A K Q J

♠ —
♥ A K J 9 8 5 3
♦ K J
♣ 10 8 7 5

Howard Schenken, the famous American Master, defended this hand in the Cavendish Club, New York. His partner was a player of modest ability, and Schenken decided that this was no time for half-measures. At trick three he made the spectacular discard of ♠A! With the ♠K clearly visible in the dummy East had really no option but to continue with a hesitant ♣Q. His puzzled frown gave way to enthusiastic praise when he appreciated the skill of his partner's discard.

P–65. Solution

It certainly is not! It is 2–1 on, that the gambler will win. In other words, he will win 2 games out of 3.

We are not dealing with cards here but with sides. There were 6 sides to begin with: 3 gold and 3 silver. The card on the table cannot be the silver/silver card, so that variant can be eliminated. We are thus left with 3 gold sides and 1 silver. We can see one gold side, so we are left with 2 gold sides and 1 silver. The reverse side can be gold, or gold, or silver. Odds 2–1 on.

B–66.

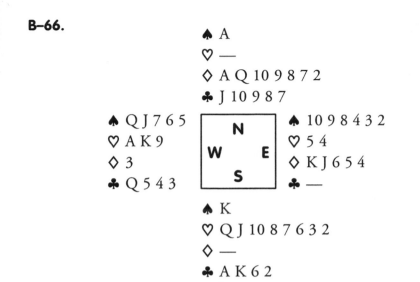

♠ A
♡ —
◊ A Q 10 9 8 7 2
♣ J 10 9 8 7

♠ Q J 7 6 5
♡ A K 9
◊ 3
♣ Q 5 4 3

N
W E
S

♠ 10 9 8 4 3 2
♡ 5 4
◊ K J 6 5 4
♣ —

♠ K
♡ Q J 10 8 7 6 3 2
◊ —
♣ A K 6 2

South to make 6 Clubs. West leads the ◊3. Can you make your contract against best defence?

P–66. Two discs

Consider the two equal circular discs, A and B, in the figure.

If B is kept fixed and A is rolled around B without slipping, how many revolutions will A have to make about its own centre when it is back in its original position?

B–66. Solution

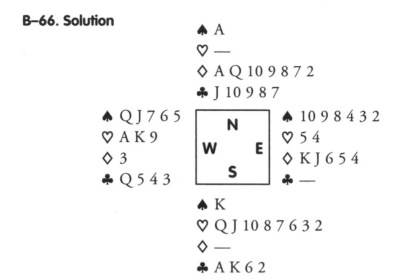

```
              ♠ A
              ♡ —
              ◇ A Q 10 9 8 7 2
              ♣ J 10 9 8 7
♠ Q J 7 6 5                      ♠ 10 9 8 4 3 2
♡ A K 9          N               ♡ 5 4
◇ 3           W     E            ◇ K J 6 5 4
♣ Q 5 4 3        S               ♣ —
              ♠ K
              ♡ Q J 10 8 7 6 3 2
              ◇ —
              ♣ A K 6 2
```

Whichever Diamond south plays from dummy at trick one, he must ruff in his hand, with the ♣2. A high Heart is covered by West and ruffed in dummy. South returns to his hand with a Club and plays a second Heart honour. West again covers and dummy ruffs. South takes his second Club honour and his top Heart, throwing the ♠A from dummy. Hearts are continued until West ruffs. (A) If West ruffs low, dummy over-ruffs. South gets back by ruffing a Diamond and continues Hearts. West can make only his master trump. (B) If West ruffs high, dummy under-ruffs! Either black suit now led by West puts south in to score his remaining Hearts.

P–66. Solution

Let P be the extreme left-hand point of A when A is in its original position. When A has completed half its circuit about B, the arc of the shaded portion of A will have been laid out along that of the shaded portion of B, and P will again be the extreme left-hand point of A. Hence A must have made one revolution.

B–67.

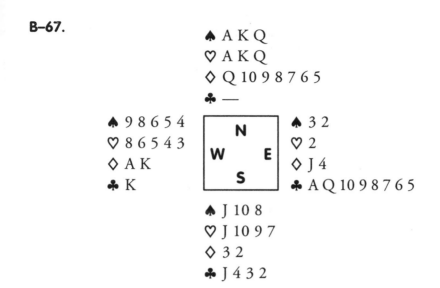

```
              ♠ A K Q
              ♡ A K Q
              ◊ Q 10 9 8 7 6 5
              ♣ —
♠ 9 8 6 5 4    ┌─────────┐    ♠ 3 2
♡ 8 6 5 4 3    │    N    │    ♡ 2
◊ A K          │ W     E │    ◊ J 4
♣ K            │    S    │    ♣ A Q 10 9 8 7 6 5
              └─────────┘
              ♠ J 10 8
              ♡ J 10 9 7
              ◊ 3 2
              ♣ J 4 3 2
```

South to make 3 no trumps. West leads the ♣K. There is more to this than meets the eye. Against best defence, it requires a genius line of play to make.

P–67. Bridge clearance

A trucker wants to driver under a bridge but finds that his rig is an inch higher than the bridge's clearance. The frustrated driver pulls to the side of the road and is checking maps to find his shortest alternative route when a small child comes up to him and says, 'Hey, Mister, for five bucks I'll tell you how to get your truck through.'

Her suggestion worked. What was it?

B–67. Solution

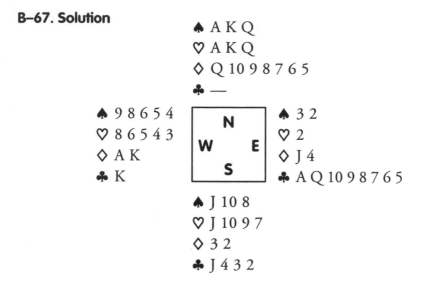

♠ A K Q
♡ A K Q
◇ Q 10 9 8 7 6 5
♣ —

♠ 9 8 6 5 4
♡ 8 6 5 4 3
◇ A K
♣ K

N
W E
S

♠ 3 2
♡ 2
◇ J 4
♣ A Q 10 9 8 7 6 5

♠ J 10 8
♡ J 10 9 7
◇ 3 2
♣ J 4 3 2

East overtakes his partner's lead with the ♣A and plays two more Clubs. West discards his two Diamond honours to unblock, giving East an entry. South discards his three top Hearts, and takes the third Club with the Jack. He now cashes the Hearts, discarding dummy's Spades. West is thrown in with the fourth Heart and has to lead into South's Spades, as East is squeezed.

P–67. Solution

The child's solution was elementary. 'Let some air out of your tyres,' she said, 'until the truck is low enough to pass under the bridge.'

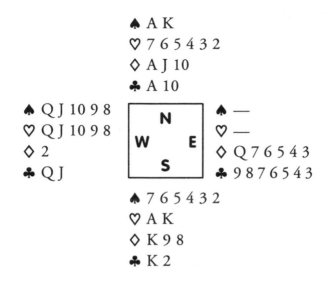

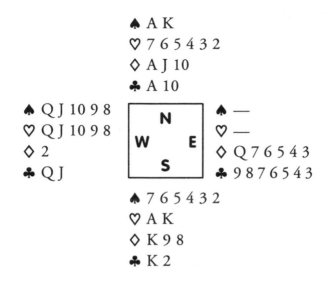

B–68.

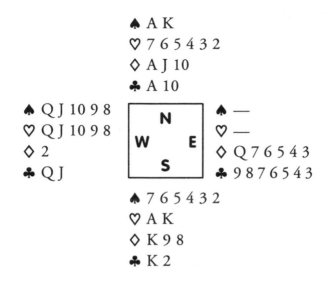

♠ A K
♥ 7 6 5 4 3 2
⋄ A J 10
♣ A 10

♠ Q J 10 9 8
♥ Q J 10 9 8
⋄ 2
♣ Q J

♠ —
♥ —
⋄ Q 7 6 5 4 3
♣ 9 8 7 6 5 4 3

♠ 7 6 5 4 3 2
♥ A K
⋄ K 9 8
♣ K 2

Declarer plays 4 no trumps. West leads the ⋄2.

P–68. Tossing pennies

Jill offered Jack the following bet: she said she would toss 3 pennies in the air, and if they fell all heads or all tails she would give him £1. If they fell any other way, he had to give her 50p.

Should Jack accept?

B–68. Solution

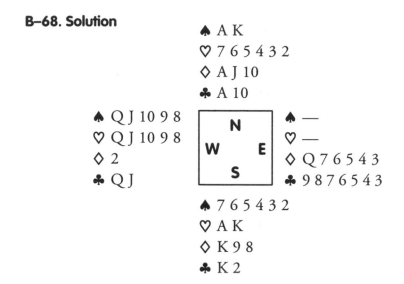

♠ A K
♡ 7 6 5 4 3 2
◊ A J 10
♣ A 10

♠ Q J 10 9 8
♡ Q J 10 9 8
◊ 2
♣ Q J

♠ —
♡ —
◊ Q 7 6 5 4 3
♣ 9 8 7 6 5 4 3

♠ 7 6 5 4 3 2
♡ A K
◊ K 9 8
♣ K 2

Declarer plays the ◊10 from dummy and ducks East's Queen. If East plays a Club, South wins in dummy, comes back to his ♣K and leads the ◊9 to the Jack. If East returns a Diamond instead of Clubs, then the ◊AK will force West to discard the Clubs. Then South will play the ♣2 and play the ♣10 or ♣A from dummy depending on West's discards.

P–68. Solution

No, it would be unwise of Jack to accept the bet. Consider all the possible ways that the 3 coins can fall, as shown in the box. Each of the 8 possibilities is equally likely, but only 2 of them show all the coins alike. So the chances of all 3 coins being alike are 2 out of 8, or one quarter. There are 6 ways that the coins can fall without being all alike. So the chances that this will happen are three-quarters. In the long run, Jill would

1. H	H	H
2. H	H	T
3. H	T	H
4. H	T	T
5. T	H	H
6. T	H	T
7. T	T	H
8. T	T	T

expect to win 3 tosses out of every 4. For these wins Jack would pay her £1.50. For the one time that Jack would win, she would pay him £1. This gives Jill a profit of 50p for every 4 tosses on average.

B–69.

♠ 10 9 6 4 2
♡ J 10 9 6 4
◊ —
♣ Q 6 4

```
        N
    W       E
        S
```

♠ A K J
♡ A Q
◊ A K J 10
♣ A K J 10

South plays 6 no trumps. West leads the ♣9. How do you proceed?

P–69. Counterfeit coins

In the figure are 10 stacks of coins, each consisting of 10 silver dollars. One entire stack is counterfeit, but you do not know which one. You do know the weight of a genuine silver dollar, and you are also told that each counterfeit coin weighs 1 gramme more or less than a genuine coin. You have a pointer scale which you use to weigh the coins.

What is the smallest number of weighings needed to determine which of the stacks is counterfeit?

B–69. Solution

♠ 10 9 6 4 2
♡ J 10 9 6 4
◊ —
♣ Q 6 4

```
    ┌─────────┐
    │    N    │
    │ W     E │
    │    S    │
    └─────────┘
```

♠ A K J
♡ A Q
◊ A K J 10
♣ A K J 10

Declarer wins in hand and leads the ♡Q. The defenders cannot afford to take the trick or dummy's Hearts will provide the discards for the Diamonds. South then follows with the ♠J, and the contract cannot be beaten.

P–69. Solution

Only a single weighing is necessary to identify the counterfeit stack. Let x be the weight of a genuine silver dollar. Take 1 coin from stack No. 1, 2 from stack No. 2, 3 from stack No. 3, and so on to the entire 10 coins from stack No. 10. Weight the whole sample. The sample should weigh $55x$. The number of grammes over or under $55x$ the sample weighs corresponds to the number of the stack containing the counterfeit coins. For instance, if the sample weighs 7 grammes more than it should (or 7 grammes less), then the stack containing the counterfeit coins is No. 7.

B–70.

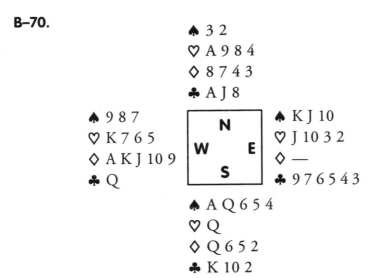

♠ 3 2
♡ A 9 8 4
◊ 8 7 4 3
♣ A J 8

♠ 9 8 7
♡ K 7 6 5
◊ A K J 10 9
♣ Q

N
W E
S

♠ K J 10
♡ J 10 3 2
◊ —
♣ 9 7 6 5 4 3

♠ A Q 6 5 4
♡ Q
◊ Q 6 5 2
♣ K 10 2

South plays 3 Spades. West leads the ♣Q. Can the contract be made against best defence?

P–70. Relations

'Jean is my niece,' said Jack to his sister Jill.

'She is not my niece,' said Jill.

Can you provide more than one possible explanation?

B–70. Solution

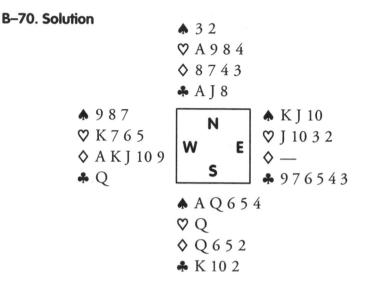

♠ 3 2
♡ A 9 8 4
◊ 8 7 4 3
♣ A J 8

♠ 9 8 7
♡ K 7 6 5
◊ A K J 10 9
♣ Q

♠ K J 10
♡ J 10 3 2
◊ —
♣ 9 7 6 5 4 3

♠ A Q 6 5 4
♡ Q
◊ Q 6 5 2
♣ K 10 2

Dummy's ♣A takes the trick, South discarding the King. A Spade is led and finessed. South now plays the ♡Q, taken by the Ace. The ♡9 is covered by East and trumped. South now exits with Ace and a small trump. East plays the ♣9, South drops the 10 and takes the trick in dummy. The ♡8 is covered and trumped. Dummy is re entered with ♣8, to throw West in with the ♡4. West is endplayed.

P–70. Solution

Jill is Jean's mother; alternatively, Jean is the daughter of Jack's wife's brother or sister.

B–71.

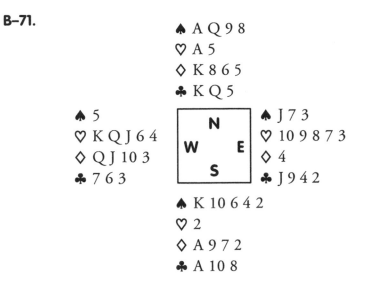

♠ A Q 9 8
♡ A 5
◇ K 8 6 5
♣ K Q 5

♠ 5
♡ K Q J 6 4
◇ Q J 10 3
♣ 7 6 3

♠ J 7 3
♡ 10 9 8 7 3
◇ 4
♣ J 9 4 2

♠ K 10 6 4 2
♡ 2
◇ A 9 7 2
♣ A 10 8

The contract is 6 Spades by South. West leads the ♡K. How do you plan your play?

P–71. Flags

The illustration shows the flats of Pakistan (left) and Algeria (right). The flags of the Comoro Islands, Mauritania and Tunisia have similar designs.

Astronomically, is there anything 'wrong' with them?

B–71. Solution

♠ A Q 9 8
♡ A 5
◇ K 8 6 5
♣ K Q 5

♠ 5
♡ K Q J 6 4
◇ Q J 10 3
♣ 7 6 3

♠ J 7 3
♡ 10 9 8 7 3
◇ 4
♣ J 9 4 2

♠ K 10 6 4 2
♡ 2
◇ A 9 7 2
♣ A 10 8

You must look for a way to avoid two Diamond losers when that suit breaks 4–1. Declarer won the Heart lead, drew trumps in three rounds, and ruffed a Heart, eliminating the suit. He next cashed three rounds of Clubs, eliminating that suit. He then led the ◇2 from his hand. West played the ◇3 and the dummy the ◇5! Declarer now had 12 tricks, despite the 4–1 break. If East had won with a singleton Diamond honour, he would have been endplayed, forced to give a ruff-and-discard. If East had won with an honour from Q-J-10-4, he would have had to exit with another honour, won with dummy's King, and declarer could then have picked up the rest of the suit. On the actual layout it would make no difference if West had inserted a high Diamond on the first round. Declarer would duck in dummy, endplaying West. The contract was cold, however the Diamonds lay.

P–71. Solution

The flags show a star shining between the horns of a crescent moon. Since this area is merely the unlit portion of the moon, any stars that might be in that part of the sky would be hidden from view.

B–72.

♠ A 8 7 5 4
♡ 4
◊ A 4
♣ A Q 10 5 4

```
        N
    W       E
        S
```

♠ K Q J 10 9 6
♡ A 9 6
◊ 9 6
♣ 9 6

Declarer to make 6 Spades against any distribution. West leads the ♡K, East plays the ♡4.

P–72. Gauss's problem

One day, one of Gauss's elementary school teachers asked the class to work quietly at their desks and add up the first 100 whole numbers. That'll keep the little devils busy for a while, the teacher assumed. But hardly had the teacher finished speaking—and hardly had the other children progressed beyond 1+2+3=6—when nine-year-old Gauss walked up to the teacher's desk and handed him the answer. The teacher didn't know whether to be more annoyed by Gauss's impertinence, or by the fact that his answer was correct.

(For the record, it is true that people are occasionally born with the phenomenal ability to perform mathematical functions in their heads at lightning speed; but Gauss was not one of them.)

How did Gauss do it?

B–72. Solution

♠ A 8 7 5 4
♡ 4
◇ A 4
♣ A Q 10 5 4

```
      N
  W       E
      S
```

♠ K Q J 10 9 6
♡ A 9 6
◇ 9 6
♣ 9 6

South takes the ♡A then two rounds of Spades, followed by the ♣6 to dummy's ♣A. Coming to hand with Spades, declarer plays the ♣9, playing low in dummy. This guarantees two tricks in Clubs irrespective of distribution.

P–72. Solution

Rather than add the numbers 1+2+3… 100 consecutively, Gauss realised that the total was made up of 50 sums of 101, made up of the first and last numbers in the series, gradually approaching the middle of the series: 1+100; 2+99, 3+98… 50+51. 50 × 101 yields the total, 5,050.

B–73.

♠ 10 9 8 7 6
♡ —
♢ A 9 8 7 6 4
♣ A K

```
    N
 W     E
    S
```

♠ A K Q J
♡ A 4 2
♢ —
♣ Q J 10 9 8 7

South to make 7 Spades against any distribution. West leads the ♢K to which east contributes the ♢3.

P–73. Checkmate

Just as I entered my chess club, I saw Michael declare checkmate. He and his opponent shook hands and proceeded to the bar. I looked at the board (right) and found that White had indeed mated Black, but how had he done it?

B–73. Solution

♠ 10 9 8 7 6
♡ —
◊ A 9 8 7 6 4
♣ A K

```
┌─────────────┐
│      N      │
│  W       E  │
│      S      │
└─────────────┘
```

♠ A K Q J
♡ A 4 2
◊ —
♣ Q J 10 9 8 7

Dummy's ◊A takes the trick, discarding a Club in hand. South uses two Spade entries to ruff two low small Hearts. He then makes two more Spades, discarding the ♣A from the dummy. Now the ♡A is played and the ♣K is discarded, leaving declarer's hand high.

P–73. Solution

Remove the white Pawn from B6 to K4 and place a black Pawn on Black's KB2. Now White plays P to K5, check, and Black must play P to B4. Then White plays P, takes P en passant, checkmate. This was therefore White's last move, and leaves the position shown. It is the only possible solution.

B–74.

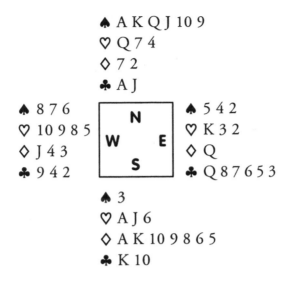

 ♠ A K Q J 10 9
 ♡ Q 7 4
 ◇ 7 2
 ♣ A J

♠ 8 7 6 ♠ 5 4 2
♡ 10 9 8 5 N ♡ K 3 2
◇ J 4 3 W E ◇ Q
♣ 9 4 2 S ♣ Q 8 7 6 5 3

 ♠ 3
 ♡ A J 6
 ◇ A K 10 9 8 6 5
 ♣ K 10

South plays 7 no trumps. West leads the ♡10, which is taken by declarer's Jack. Can the contract be made?

P–74. The three cities

If city A is 9,000 miles from London, and London is 9,000 miles from city B, prove by reasoning that city A must be closer to city B than 9,000 miles.

B–74. Solution

```
              ♠ A K Q J 10 9
              ♡ Q 7 4
              ◊ 7 2
              ♣ A J
♠ 8 7 6                        ♠ 5 4 2
♡ 10 9 8 5         N           ♡ K 3 2
◊ J 4 3        W       E       ◊ Q
♣ 9 4 2            S           ♣ Q 8 7 6 5 3
              ♠ 3
              ♡ A J 6
              ◊ A K 10 9 8 6 5
              ♣ K 10
```

Yes, but only by adopting a brilliant line. Play the ◊A, cross to the dummy with Spades, and led the ♡Q to transfer the menace. Run off all the black winners, and a simple squeeze gives you the contract. If East does not cover the ♡Q, run it; West is most unlikely to have led from a King against a 7 no trump contract.

P–74. Solution

Taking the Earth's circumference as 25,000 miles, cities A and B are anywhere from zero to 7,000 miles apart, as the greatest distance between the three cities must lie on a great circle, approximately equal to the circumference measured at the equator.

B–75.

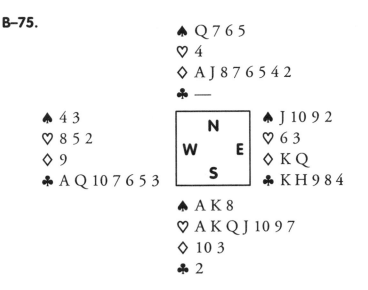

♠ Q 7 6 5
♡ 4
◊ A J 8 7 6 5 4 2
♣ —

♠ 4 3
♡ 8 5 2
◊ 9
♣ A Q 10 7 6 5 3

♠ J 10 9 2
♡ 6 3
◊ K Q
♣ K H 9 8 4

♠ A K 8
♡ A K Q J 10 9 7
◊ 10 3
♣ 2

South plays 6 Hearts. West leads the ♡2, which proves a killing lead. Is the contract still makable?

P–75. Mate in one

How did White mate in one move?

B–75. Solution

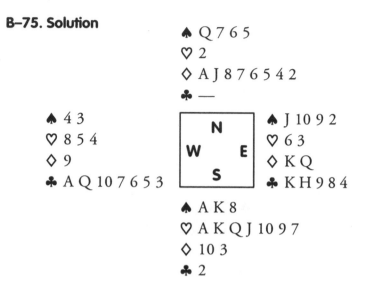

♠ Q 7 6 5
♡ 2
♢ A J 8 7 6 5 4 2
♣ —

♠ 4 3
♡ 8 5 4
♢ 9
♣ A Q 10 7 6 5 3

♠ J 10 9 2
♡ 6 3
♢ K Q
♣ K H 9 8 4

♠ A K 8
♡ A K Q J 10 9 7
♢ 10 3
♣ 2

Yes, if declarer rectifies the count by leading the ♣2. Later the ♢A is played, and a squeeze against East is on the cards.

P–75. Solution

I apologise for this trick question!

Since chess is played with a white square at each player's near right corner of the board, the players must be at the left and right sides of the board illustrated. Therefore, whether White is moving to the left or to the right, he wins by queening his Pawn: P–B8 (Queen), mate.

B–76.

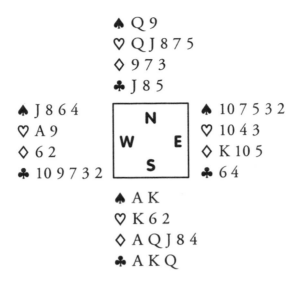

The contract is 6 no trumps, played by South. West leads the ♣10. Can declarer make it against best defence?

P–76. The crossroads

George was proud of his new turbo coupe Rover. He was driving north at 50 miles per hour, well within the speed limit, when a black Nissan, travelling at high speed, collided with his Rover at a crossroads, and severely damaged it. George, knowing he had right of way, was furious. He was on the point of blasting the driver of the Nissan with an effusion of four-letter words, when a gorgeous creature stepped out of the Nissan, and with the sweetest of smiles, accepted full responsibility and apologised profusely.

They moved their cars off the road, so as not to impede traffic. George was utterly captivated by this beautiful woman. After exchanging first names she suggested that they celebrate their newly found friendship. She produced a bottle of Grand Marnier and two glasses which she filled to the brim and toasted: 'To us!' George was happy to oblige, but was perplexed to see that she poured her own drink onto the ground.

Why did she behave so offensively?

B–76. Solution

♠ Q 9
♡ Q J 8 7 5
◊ 9 7 3
♣ J 8 5

♠ J 8 6 4
♡ A 9
◊ 6 2
♣ 10 9 7 3 2

♠ 10 7 5 3 2
♡ 10 4 3
◊ K 10 5
♣ 6 4

♠ A K
♡ K 6 2
◊ A Q J 8 4
♣ A K Q

No! To make 12 tricks, declarer needs two entries into dummy to finesse Diamonds twice. West can prevent it. If South plays the ♡K, West ducks. If South plays a small Heart, West takes with the ♡A and returns the ♡9.

P–76. Solution

George, somewhat piqued, asked her:

'Aren't you going to drink?'

'Not until the police have been here,' she replied, removing the bottle and glasses.

B–77.

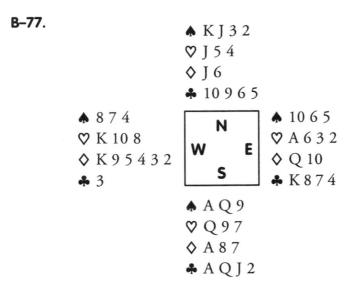

 ♠ K J 3 2
 ♥ J 5 4
 ◇ J 6
 ♣ 10 9 6 5

♠ 8 7 4 ♠ 10 6 5
♥ K 10 8 ♥ A 6 3 2
◇ K 9 5 4 3 2 ◇ Q 10
♣ 3 ♣ K 8 7 4

 ♠ A Q 9
 ♥ Q 9 7
 ◇ A 8 7
 ♣ A Q J 2

South plays 3 no trumps. West leads the ◇4. Can the contract be made, assuming that South is unaware of East's and West's distribution? South holds up the Diamonds twice.

P–77. Death in Squaw Valley

A New York banker and his wife took their annual skiing holiday in the Valley. Late one afternoon, in bad visibility, the wife skidded over a precipice and broke her neck. The coroner returned a verdict of accidental death and released the body for burial.

In New York an airline clerk read about the accident. He contacted the police and gave them some information which resulted in the husband's arrest and indictment for first-degree murder. The clerk did not know the banker or his wife, and had never been to Squaw Valley.

What information did he give the police?

B–77. Solution

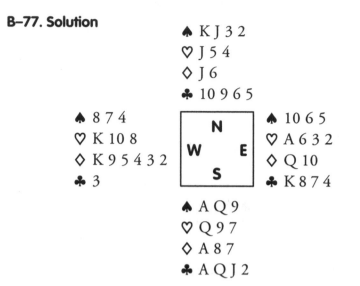

♠ K J 3 2
♡ J 5 4
◊ J 6
♣ 10 9 6 5

♠ 8 7 4 ♠ 10 6 5
♡ K 10 8 ♡ A 6 3 2
◊ K 9 5 4 3 2 ◊ Q 10
♣ 3 ♣ K 8 7 4

♠ A Q 9
♡ Q 9 7
◊ A 8 7
♣ A Q J 2

If West has an entry with the ♣K, the contract fails. Consequently he must find two entries into dummy to finesse East. He can test whether Spades will provide two entries by playing the ♠Q to the King. West will surely signal his length by playing the ♠4.

P–77. Solution

The clerk remembered having issued flight tickets to the banker, who had booked a round trip for himself and a one-way ticket for his wife.

B–78.

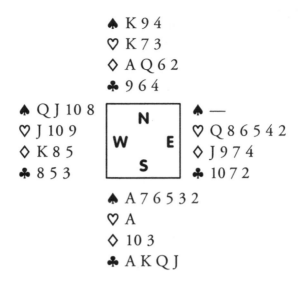

♠ K 9 4
♡ K 7 3
♢ A Q 6 2
♣ 9 6 4

♠ Q J 10 8
♡ J 10 9
♢ K 8 5
♣ 8 5 3

♠ —
♡ Q 8 6 5 4 2
♢ J 9 7 4
♣ 10 7 2

♠ A 7 6 5 3 2
♡ A
♢ 10 3
♣ A K Q J

The Contract is 6 Spades by South. West leads the ♡J. How do you plan the play?

P–78. Crafty cabby

In his book *Aha! Insight,* master gamesman Martin Gardner tells the story of a talkative, highly-strung woman who hailed a taxi-cab in New York City. During the journey the lady talked so much that the taxi driver got quite annoyed. He said, 'I'm sorry lady, but I can't hear a word you're saying. I'm deaf as a post, and the battery in my hearing aid is dead.' This shut the woman up, but after she left the cab she figured out he had been lying to her.

How did she know?



B–78. Solution

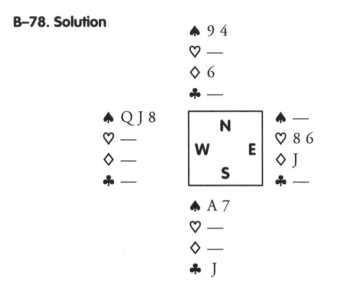

The slam is safe, provided the trumps are not 4–0. South, in his hand with the ♡A, being a careful player, continued with a small Spade intending to insert dummy's ♠9 if West followed low. West, however played ♠10, won by dummy's King, East discarding a Heart. Now, the only chance for avoiding two trump losers was a trump reducing play, combined with an endplay against West.

Accordingly, South ruffed a Heart in the closed hand and finessed ◊Q. Next ♡K was ruffed, followed by a Diamond to dummy's ◊A. A diamond ruff was followed by three top Clubs, leaving the position illustrated above.

South continued with ♣J and West was free to ruff in with a trump honour. Dummy discarded ◊6 and South won the last two tricks with his combined tenace.

P–78. Solution

The woman realised the cabby could hear, because he drove her to her requested destination.

B–79.

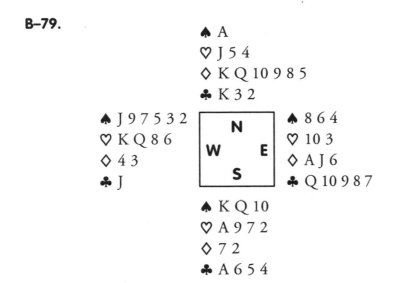

```
                    ♠ A
                    ♡ J 5 4
                    ◇ K Q 10 9 8 5
                    ♣ K 3 2
  ♠ J 9 7 5 3 2    ┌─────────┐    ♠ 8 6 4
  ♡ K Q 8 6        │    N    │    ♡ 10 3
  ◇ 4 3            │  W   E  │    ◇ A J 6
  ♣ J              │    S    │    ♣ Q 10 9 8 7
                    └─────────┘
                    ♠ K Q 10
                    ♡ A 9 7 2
                    ◇ 7 2
                    ♣ A 6 5 4
```

The contract is 3 no trumps played by South. West leads the ♠5. Plan your play.

P–79. The missing £

This is a very old English puzzle. Three men dined in a restaurant and the bill came to £25.

Each man gave the waiter £10 and told him to keep £2 out of the change as a tip.

The waiter returned with £3 and proceeded to give each man £1.

The meal had therefore cost £27 plus £2 for the waiter's tip. Where had the other £1 gone?

B–79. Solution

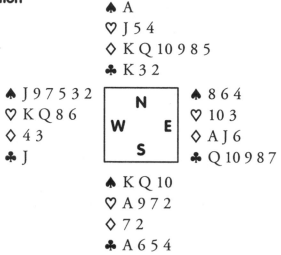

♠ A
♡ J 5 4
◇ K Q 10 9 8 5
♣ K 3 2

♠ J 9 7 5 3 2
♡ K Q 8 6
◇ 4 3
♣ J

♠ 8 6 4
♡ 10 3
◇ A J 6
♣ Q 10 9 8 7

♠ K Q 10
♡ A 9 7 2
◇ 7 2
♣ A 6 5 4

Having won with ♠A, South should continue with ◇10. By this move, he guards against the actual layout, keeping his communications open to dummy. Regardless of what the defence does, South will make his contract with an overtrick.

P–79. Solution

The way the question is posed includes a piece of mathematical sleight of hand. It suggests that each man spent £9 plus £2 tip between them, but the £27 included the tip.

We should say:

The meal cost	£25
The waiter's tip	2
Change	3
	£30

B–80.

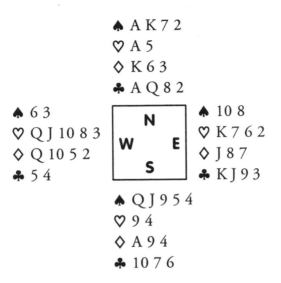

 ♠ A K 7 2
 ♡ A 5
 ◊ K 6 3
 ♣ A Q 8 2

♠ 6 3 ♠ 10 8
♡ Q J 10 8 3 N ♡ K 7 6 2
◊ Q 10 5 2 W E ◊ J 8 7
♣ 5 4 S ♣ K J 9 3

 ♠ Q J 9 5 4
 ♡ 9 4
 ◊ A 9 4
 ♣ 10 7 6

South plays 4 Spades. West leads the ♡Q. How would you plan your play?

P–80. Where are you?

Suppose you are a passenger in a doughnut-shaped space station. It is spinning around its hub to produce a simulated gravity of 1 g, exactly mimicking the gravity of Earth. You are in a small, windowless room, so you cannot see the rest of the space station. Inside your room everything seems 'normal'—gravity seems to be operating on you exactly as it would on Earth. In fact, as far as your senses can tell you, you are on Earth.

You have a coin in your pocket. Is there a simple test you could do in your room that would confirm you are on a spinning space station and not on Earth?

B–80. Solution

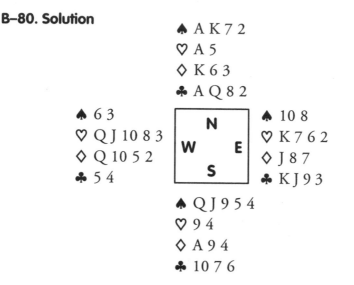

♠ A K 7 2
♡ A 5
◊ K 6 3
♣ A Q 8 2

♠ 6 3
♡ Q J 10 8 3
◊ Q 10 5 2
♣ 5 4

♠ 10 8
♡ K 7 6 2
◊ J 8 7
♣ K J 9 3

♠ Q J 9 5 4
♡ 9 4
◊ A 9 4
♣ 10 7 6

You win the opening lead and draw trumps in two rounds. You must now seek the safest way to play the Club suit, to generate two tricks in the suit (So you can throw a Diamond). the best play is to cash the ♣A, then lead low to the 10. This will succeed around 95 percent of the time.

P–80. Solution

Try to spin one of your coins on the floor of your room: the coin will refuse to spin. By conservation of angular momentum, a spinning object tries to maintain its position in space. Since the spinning station is continually changing your position in space, a coin that is spun will keep changing its orientation to correct its angular momentum, and will topple and fall.

5. Magician's Wand

Time bomb

Here is a design for a bomb that requires no explosives. Imagine that the bomb was made of a material that was a perfect reflector of sound. Inside it has a spherical cavity. At the centre of this cavity sits a ticking watch. The sound inside will build up, as it cannot escape. Eventually the sound energy would be so great that it could no longer be contained. At this point the bomb would explode.

Would this design work?

Time bomb. Solution

The design would not work. First, there is no such thing as a perfect reflector of sound. Second, the amount of energy in a watch is quite small. But even without these two objections, the proposal would still be impractical.

Air is a very inefficient transmitter of sound, and consequently sound energy is continually being converted into heat. The energy thus escapes from the sphere in the form of heat.

A NOTE ABOUT THIS CHAPTER

The hands in this chapter are of special interest, having been played in national or world championships or in leading bridge clubs.

Why of special interest? Because declarers, many with international reputations, failed with their contracts, when a superior line of play would have succeeded.

B–81.

♠ A K J 9
♡ A J 6
◇ A K 4
♣ 7 5 3

♠ 7
♡ 9 7 5 3 2
◇ Q 10 7 5
♣ K 10 8

♠ 10 8 6 4 3
♡ Q 8 4
◇ 2
♣ J 9 4 2

♠ Q 5 2
♡ K 10
◇ J 9 8 6 3
♣ A Q 6

South plays 6 no trumps. West led the ♡3. Declarer was **one down**, but could the contract be made?

P-81. The deadly scotch

Mr El and Mr Lay went into a bar, and each ordered a scotch on the rocks. Unknown to them, they both got drinks laced with poison. Mr El downed his in one gulp and proceeded to chat for an hour while Mr Lay drank his slowly. Later, Mr Lay died, but Mr El didn't. Why?

B–81. Solution

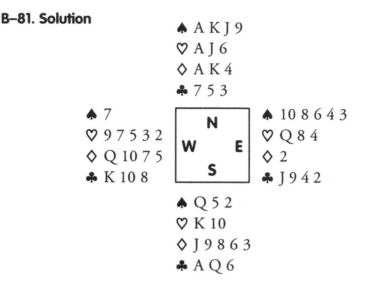

```
              ♠ A K J 9
              ♡ A J 6
              ◇ A K 4
              ♣ 7 5 3
♠ 7                           ♠ 10 8 6 4 3
♡ 9 7 5 3 2      N            ♡ Q 8 4
◇ Q 10 7 5   W     E          ◇ 2
♣ K 10 8         S            ♣ J 9 4 2
              ♠ Q 5 2
              ♡ K 10
              ◇ J 9 8 6 3
              ♣ A Q 6
```

South elected to cash out dummy's top Diamonds, disclosing the bad break, when East dropped a Spade. Now, there was no hope, so south conceded two Diamond tricks for **down one**.

Let us see what South could have done to guard against the actual layout. In order to assure a later Heart entry to the closed hand, South should play dummy's ♡J at trick 1. Next, ◇A is cashed, followed by a Heart to the ten. South then leads ◇9, intending to play ◇K and ◇4. if West showed out. Here, however, West must play ◇7 to block the suit. According to plan, South lets ◇9 ride, East dropping his last Heart. ◇K follows and after a Spade to ♠Q, South concedes a Diamond to West's Queen, making the balance.

P–81. Solution

The poison was inside the ice cubes, which dissolved in Lay's drink but not in El's.

B–82.

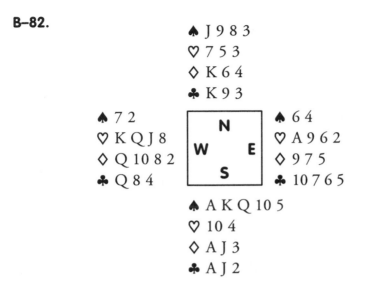

♠ J 9 8 3
♡ 7 5 3
◊ K 6 4
♣ K 9 3

♠ 7 2
♡ K Q J 8
◊ Q 10 8 2
♣ Q 8 4

♠ 6 4
♡ A 9 6 2
◊ 9 7 5
♣ 10 7 6 5

♠ A K Q 10 5
♡ 10 4
◊ A J 3
♣ A J 2

South plays 4 Spades. West leads the ♡K. Declarer, a good player, adopted a perfectly reasonable line of play, yet he was **one down**. Can you do better?

P–82. The cabin in the woods

There is an old German fairy-tale of two children, Hansel and Gretel, taking a stroll into the nearby woods and suddenly discovering a log cabin covered with mouth-watering chocolate cookies, the home of a wicked witch.

Our story is also about Hansel and Gretel, members of the village constabulary, who were ordered to search the forest which surrounded their neighbourhood. They too came upon a cabin, but to their horror found it full of dead men, women and children. They did not die of natural causes and no crime was involved.

What do you think had happened?

B–82. Solution

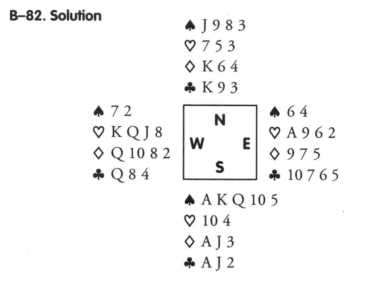

♠ J 9 8 3
♡ 7 5 3
◊ K 6 4
♣ K 9 3

♠ 7 2
♡ K Q J 8
◊ Q 10 8 2
♣ Q 8 4

♠ 6 4
♡ A 9 6 2
◊ 9 7 5
♣ 10 7 6 5

♠ A K Q 10 5
♡ 10 4
◊ A J 3
♣ A J 2

The defence started with three rounds of Hearts, South ruffing. ♠A and ♠K cleared trumps. Now, odds were 3–1 for East holding at least one of the minor suit Queens, so South crossed to dummy's ◊K, finessing ◊J. West, however, won the ◊Q, exiting with a Diamond. South gained the lead and when the Club finesse also failed, the result was **down one**.

South's plan was not bad, but there was a slightly better one, which pays regard to the presence of dummy's ♣9. Having cleared trumps, South plays three rounds of Diamonds. Now, should West win as in the actual layout, he is endplayed. Supposing East shows up with ◊Q, he is forced to return a Club. At this moment, South still has a 3–1 proposition left for East holding either ♣10 or ♣Q. South plays ♣2, forcing West's Queen. Had West shown up with ♣10, South of course finesses ♣J.

P–82. Solution

The night before, an explosion was heard and a fireball in the air noticed by several villagers who, assuming it to be a plane crash, reported it to the constabulary. Hansel and Gretel were sent out to investigate. What they discovered in the woods was the cabin of an aeroplane.

B–83.

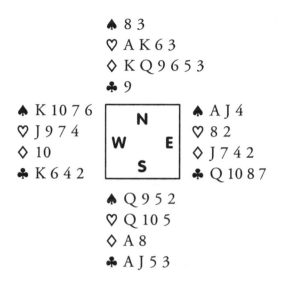

♠ 8 3
♥ A K 6 3
♦ K Q 9 6 5 3
♣ 9

♠ K 10 7 6
♥ J 9 7 4
♦ 10
♣ K 6 4 2

♠ A J 4
♥ 8 2
♦ J 7 4 2
♣ Q 10 8 7

♠ Q 9 5 2
♥ Q 10 5
♦ A 8
♣ A J 5 3

South is in 3 no trumps, West leading the ♥4. While South was **one down**, the contract is makeable. How?

P–83. The judgment

A man is found guilty of first-degree murder. The judge says, 'This is one of the most vicious criminal acts that has ever come before me, and I am satisfied beyond any doubt that there are no mitigating factors. I wish I could impose the stiffest sentence at my disposal, but I have no choice but to let you go.'

What is the reason for the judge's decision?

B–83. Solution

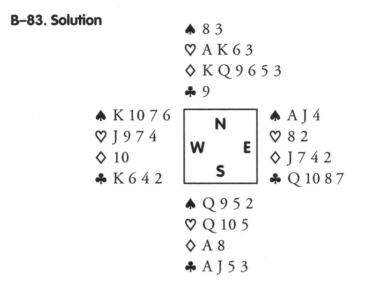

```
                    ♠ 8 3
                    ♡ A K 6 3
                    ◊ K Q 9 6 5 3
                    ♣ 9
♠ K 10 7 6                          ♠ A J 4
♡ J 9 7 4        N                  ♡ 8 2
◊ 10          W     E               ◊ J 7 4 2
♣ K 6 4 2        S                  ♣ Q 10 8 7
                    ♠ Q 9 5 2
                    ♡ Q 10 5
                    ◊ A 8
                    ♣ A J 5 3
```

West led ♡4, South's ♡10 winning. Two top Diamonds disclosed the
bad break, West discarding a Club. A small Diamond put East on lead,
South and West dropping Clubs. East now found the excellent switch to
♠J, covered by ♠Q and ♠K. West returned ♠6 to East's ♠A, and a third
round gave West two more Spade tricks for **down one**.

Here South accepted a Greek gift when winning the extra Heart trick
with ♡10. He needs only 5 Diamond tricks for his contract, and there is
no risk of losing more than 3 Spade tricks as long as East can be kept out
of lead. So South should win the Heart lead in dummy, and lead a small
Diamond, finessing ◊8 when East plays low. Now West is on lead with
◊10 but cannot do any better than cash 3 Spade Tricks.

Nine tricks to South.

P–83. Solution

The convicted killer was one of Siamese twins.

B–84.

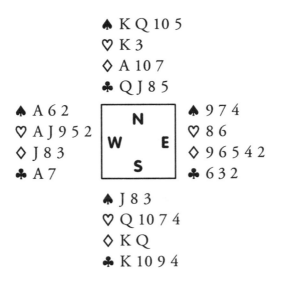

♠ K Q 10 5
♡ K 3
◇ A 10 7
♣ Q J 8 5

♠ A 6 2
♡ A J 9 5 2
◇ J 8 3
♣ A 7

♠ 9 7 4
♡ 8 6
◇ 9 6 5 4 2
♣ 6 3 2

♠ J 8 3
♡ Q 10 7 4
◇ K Q
♣ K 10 9 4

The contract is 3 no trumps by South. West leads the ♡5, after his opening bid has indicated that he holds most, if not all, outstanding points.

P–84. Cracked up

Poor hot water into a thick drinking glass and into a thin wine glass. Which glass is more likely to crack?

B-84. Solution

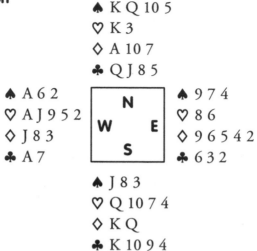

```
              ♠ K Q 10 5
              ♡ K 3
              ◇ A 10 7
              ♣ Q J 8 5
♠ A 6 2                    ♠ 9 7 4
♡ A J 9 5 2      N         ♡ 8 6
◇ J 8 3      W       E     ◇ 9 6 5 4 2
♣ A 7            S         ♣ 6 3 2
              ♠ J 8 3
              ♡ Q 10 7 4
              ◇ K Q
              ♣ K 10 9 4
```

West led ♡5, South's ♡10 winning. A small Spade followed, but West quickly went up with ♠A, clearing Hearts with ♡A and ♡J. South won with ♡Q and led a Club, but West won ♣A and two more Heart tricks for **down one**.

As so often happens, South slipped at trick one. He was too greedy, when winning cheap with ♡10. West was marked with the outside strength on his opening bid, so there was no risk of East gaining the lead. To the first trick, South should win with ♡K in dummy. He will then have plenty of time to set up the black suits for his contract.

P-84. Solution

The thick drinking glass will break first. Glass is a poor conductor of heat. In the thin wine glass, heat passes quickly from the inner to the outer surface of the glass, and the glass expands with relative uniformity. When you pour hot water into the thick glass, its inner surface expands quickly while its outer surface remains the same size; this results in enormous stress on the glass, and so it cracks.

B–85.

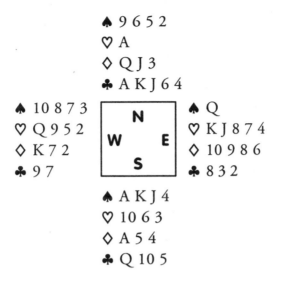

♠ 9 6 5 2
♡ A
◇ Q J 3
♣ A K J 6 4

♠ 10 8 7 3
♡ Q 9 5 2
◇ K 7 2
♣ 9 7

N
W E
S

♠ Q
♡ K J 8 7 4
◇ 10 9 8 6
♣ 8 3 2

♠ A K J 4
♡ 10 6 3
◇ A 5 4
♣ Q 10 5

South is declarer in 6 Spades. West leads the ♡2.

P–85. What are they?

'How much does one cost?' asked the customer in a hardware store. 'Twenty cents,' replied the clerk. 'And how much will twelve cost?' 'Forty cents.' 'OK. I'll take nine hundred and twelve.' 'Fine. That will be sixty cents.'

What was the customer buying?

B–85. Solution

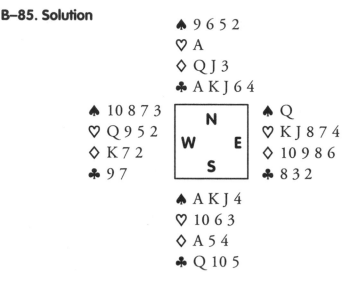

♠ 9 6 5 2
♡ A
◇ Q J 3
♣ A K J 6 4

♠ 10 8 7 3
♡ Q 9 5 2
◇ K 7 2
♣ 9 7

♠ Q
♡ K J 8 7 4
◇ 10 9 8 6
♣ 8 3 2

♠ A K J 4
♡ 10 6 3
◇ A 5 4
♣ Q 10 5

West led ♡2, dummy's ♡A winning. A small trump to the Ace was followed by a Heart ruff, and a second trump disclosed the 4–1 break, East discarding a Heart. Seeing that he was on the road to lose control entirely, South ducked the trick to West, who returned a trump. ♠K drew West's last trump, and a Diamond was discarded in dummy. South then cashed his Club tricks and tried the Diamond finesse, which lost. **One down**.

South should have taken warning from East's play of the trump Queen to the first round. West was likely to hold the guarded 10, and in that case South needed two Heart ruffs in dummy if he shouldn't be dependent on the Diamond finesse. Therefore, South should have ducked East's ♠Q. He wins the Diamond lead with ◇A and ruffs a Heart. A trump to the Ace is followed by a second Heart ruff, and the closed hand is re-entered with a Club. West's trumps are drawn, South making the balance.

P–85. Solution

House numbers.

B–86.

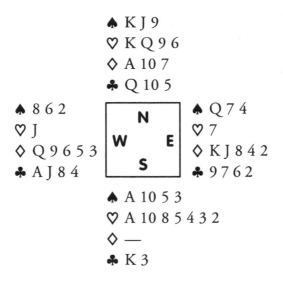

 ♠ K J 9
 ♡ K Q 9 6
 ◇ A 10 7
 ♣ Q 10 5

♠ 8 6 2 ♠ Q 7 4
♡ J ♡ 7
◇ Q 9 6 5 3 ◇ K J 8 4 2
♣ A J 8 4 ♣ 9 7 6 2

 ♠ A 10 5 3
 ♡ A 10 8 5 4 3 2
 ◇ —
 ♣ K 3

South plays 6 Hearts. West leads the ◇5.

P–86. The suspended egg

How would you make a raw egg float half way between the surface and
the bottom of a glass of water?

B–86. Solution

♠ K J 9
♡ 9 6
♢ —
♣ Q 10

♠ 8 6 2
♡ —
♢ Q
♣ J 8 4

♠ Q 7 4
♡ —
♢ J
♣ 9 7 6

♠ A 10 5 3
♡ A 10 8
♢ —
♣ —

West led ♢5, ruffed in the closed hand. A Heart to dummy's King cleared trumps, and a Club to the King was won by West. If ♣K had held the trick, South would have re-entered dummy with a trump in order to discard his last Club on ♢A. West on lead, however, returned a Club, and South, not being willing to risk the finesse at this stage, won ♣Q. Later in the play he misguessed ♠Q and went **down one.**

South's plan was not quite good enough. Having ruffed the Diamond lead, he should have crossed to dummy with a trump and discarded ♣3 on ♢A. After a second Diamond ruff, he should re-enter dummy in trumps to lead a Club to the King. Here West wins, and the position is as shown above. West has no safe exit. If he elects to lead a Spade or a Diamond, all is over. On the Club lead from West, South gets the free finesse with ♣10, making his slam without having to risk a finesse in Spades.

P–86. Solution

First fill the glass half full of water and dissolve enough salt in it to make it dense enough for the egg to flat on top. Then add more unsalted water to the top, filling to the brim.

B–87.

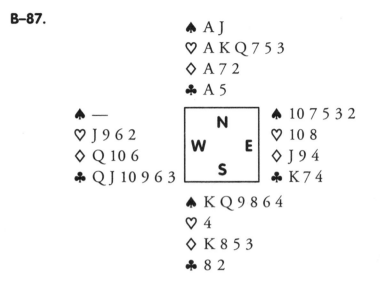

♠ A J
♡ A K Q 7 5 3
◇ A 7 2
♣ A 5

♠ —
♡ J 9 6 2
◇ Q 10 6
♣ Q J 10 9 6 3

N
W E
S

♠ 10 7 5 3 2
♡ 10 8
◇ J 9 4
♣ K 7 4

♠ K Q 9 8 6 4
♡ 4
◇ K 8 5 3
♣ 8 2

South as declarer plays 7 Spades. West leads the ♣Q.

P–87. Space station

People have speculated that, one day in the far future, it may be possible to hollow out the interior of a large asteroid or moon and use it as a permanent space station. Assuming that such a hollowed-out asteroid is a perfect, non-rotating sphere with an outside shell of constant thickness, would an object inside, near the shell, be pulled by the shell's gravity field towards the shell or towards the centre of the asteroid, or would it float permanently at the same location?

B–87. Solution

♠ A J
♡ A K Q 7 5 3
◊ A 7 2
♣ A 5

♠ —
♡ J 9 6 2
◊ Q 10 6
♣ Q J 10 9 6 3

♠ 10 7 5 3 2
♡ 10 8
◊ J 9 4
♣ K 7 4

♠ K Q 9 8 6 4
♡ 4
◊ K 8 5 3
♣ 8 2

West led the ♣Q, dummy's ♣A winning. ♠A disclosed the bad trump break, and that meant that south needed a trump coup for his contract. Having cashed ♡A and ruffed a Heart, South crossed to dummy's ♠J in order to play high Hearts. East decided to keep his trumps and discarded Diamonds every time. South, however, had to get rid of his Club loser, so he could only discard three of his Diamonds. When he finally tried to cash ◊A, East was able to ruff for **down one**.

It wouldn't have helped South to cash ◊A earlier. East would then ruff one of dummy's high Hearts, holding South to twelve tricks. The critical moment for South is at trick five when he has ruffed a Heart. The solution is to cash ◊K before he crosses to dummy's ♠J. Now East is powerless, and South can pick up his trump length, making his grand slam.

P–87. Solution

Zero gravity would prevail at all points inside a hollowed-out asteroid, so it would float permanently at the same location.

B–88.

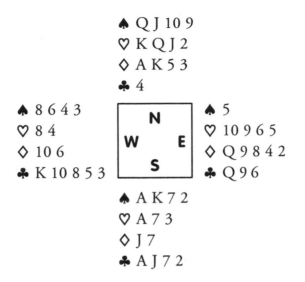

```
              ♠ Q J 10 9
              ♡ K Q J 2
              ◇ A K 5 3
              ♣ 4

♠ 8 6 4 3          N          ♠ 5
♡ 8 4         W        E      ♡ 10 9 6 5
◇ 10 6             S          ◇ Q 9 8 4 2
♣ K 10 8 5 3                  ♣ Q 9 6

              ♠ A K 7 2
              ♡ A 7 3
              ◇ J 7
              ♣ A J 7 2
```

South plays 7 Spades. West leads the ♠3.

P–88. Bird on the moon

Imagine a bird with a small, lightweight oxygen tank attached to its back so that it can breathe on the moon. Given that the pull of gravity is less than on the Earth, will the bird's flying speed on the moon be faster, slower, or the same as its speed on the Earth? Assume that, for the purposes of making the comparison, the bird has to carry the same equipment on Earth.

B–88. Solution

♠ Q J 10 9
♡ K Q J 2
◊ A K 5 3
♣ 4

♠ 8 6 4 3
♡ 8 4
◊ 10 6
♣ K 10 8 5 3

♠ 5
♡ 10 9 6 5
◊ Q 9 8 4 2
♣ Q 9 6

♠ A K 7 2
♡ A 7 3
◊ J 7
♣ A J 7 2

West led ♠3, dummy winning. South planned setting up dummy with two Diamond ruffs in the closed hand. ◊A and ◊K were cashed, and a Diamond ruffed with ♠K, West discarding a Heart. Now dummy was re-entered with a trump, and the last Diamond ruffed with ♠A. West, however, was quick to get rid of his last Heart. Because the trumps had not broken, south had to try to cross to dummy with a Heart. West was able to ruff for **down one**.

South's plan on dummy reversal was quite sound, but he overlooked the danger that befell him. Having ruffed the first Diamond, South should have crossed to dummy with a Heart first in order to ruff the last Diamond. He is now able to return to dummy with a trump to draw trumps and claim the rest.

P–88. Solution

The bird couldn't fly at all on the moon because there is no lunar air to support it.

B–89.

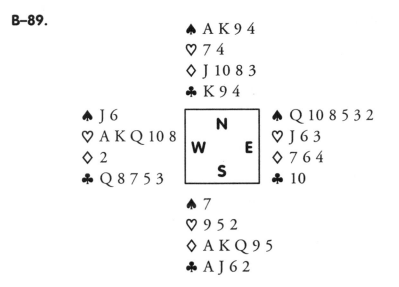

♠ A K 9 4
♡ 7 4
♦ J 10 8 3
♣ K 9 4

♠ J 6
♡ A K Q 10 8
♦ 2
♣ Q 8 7 5 3

♠ Q 10 8 5 3 2
♡ J 6 3
♦ 7 6 4
♣ 10

♠ 7
♡ 9 5 2
♦ A K Q 9 5
♣ A J 6 2

South's contract was 5 Diamonds. West played ♡A and ♡K, followed by ♠J. How do you plan the play?

P–89. The goldfish

A goldfish bowl, three-quarters full of water, is placed on a weighing scale. If a live goldfish is dropped into the water, the scale will show an increase in weight equal to the weight of the fish. However, assume that the goldfish is held by its tail so that all but the extreme tip of its tail is under water. Will this operation cause the scale to register a greater weight than it did before the fish was suspended?

B–89. Solution

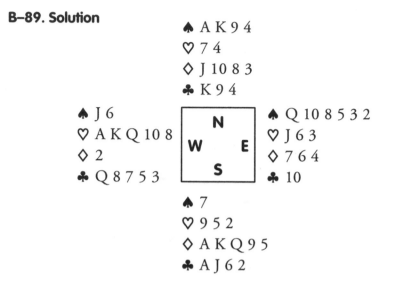

♠ A K 9 4
♡ 7 4
◇ J 10 8 3
♣ K 9 4

♠ J 6
♡ A K Q 10 8
◇ 2
♣ Q 8 7 5 3

♠ Q 10 8 5 3 2
♡ J 6 3
◇ 7 6 4
♣ 10

♠ 7
♡ 9 5 2
◇ A K Q 9 5
♣ A J 6 2

West started with two top Hearts and switched to ♠J. Dummy's ♠A won, and three rounds cleared trumps. Now South cashed ♣K and played ♣9, intending to finesse. When East showed out, however, South had to concede a trick to West's Queen for **down one**.

South played too hastily. The Club finesse could wait. Having drawn trumps ending in dummy, he should have cashed ♠K and ruffed a Spade in the closed hand. After a Heart ruff in dummy, South now has a perfect picture of West's hand. East is marked with a singleton Club, so South continues with ♣4 to the ♣A, taking the marked finesse with ♣9.

P–89. Solution

The scale registers an increase in weight equivalent to the amount of liquid displaced by the suspended goldfish.

B–90.

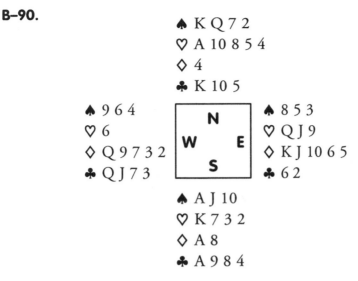

♠ K Q 7 2
♡ A 10 8 5 4
◇ 4
♣ K 10 5

♠ 9 6 4
♡ 6
◇ Q 9 7 3 2
♣ Q J 7 3

♠ 8 5 3
♡ Q J 9
◇ K J 10 6 5
♣ 6 2

♠ A J 10
♡ K 7 3 2
◇ A 8
♣ A 9 8 4

South plays 6 Hearts. West leads the ◇3.

P–90. The sharpshooter

A sharpshooter hung up his hat and put on a blindfold. He then walked 100 yards, turned around, and shot a bullet through his hat. The blindfold was a perfectly good one, completely blocking the man's vision.

How did he manage this feat?

B–90. Solution

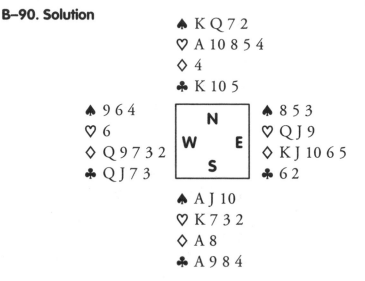

♠ K Q 7 2
♡ A 10 8 5 4
♦ 4
♣ K 10 5

♠ 9 6 4
♡ 6
♦ Q 9 7 3 2
♣ Q J 7 3

♠ 8 5 3
♡ Q J 9
♦ K J 10 6 5
♣ 6 2

♠ A J 10
♡ K 7 3 2
♦ A 8
♣ A 9 8 4

West led ◊3, South winning. The ♡K and ♡A disclosed that East had a sure trick in trumps. With his combined tenace in Clubs, South had a good chance to arrange an endplay against East.

After a Space to the Ace, South ruffed ◊8 in dummy and cashed two more Spade tricks. Now time was ripe to throw East in with a trump. A Club came back to West's ♣J and dummy's ♣K. South then tried a Club finesse over East, but West won with the ♣Q for **down one**.

South's plan was not bad since he would have made the slam with divided Club honours. However, he missed a very important point. West's opening lead of ◊3, according to the rule of eleven, clearly showed that East held at least five Diamonds. He had already shown up with three Spades and three trumps, so he could not possibly have more then two Clubs. Having followed this reasoning, South should have cashed the top Clubs before he endplayed East.

P–90. Solution

The sharpshooter's hat was hanging over the barrel of his gun.

B–91.

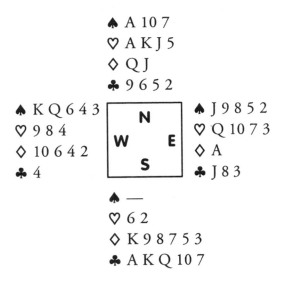

♠ A 10 7
♡ A K J 5
◊ Q J
♣ 9 6 5 2

♠ K Q 6 4 3
♡ 9 8 4
◊ 10 6 4 2
♣ 4

♠ J 9 8 5 2
♡ Q 10 7 3
◊ A
♣ J 8 3

♠ —
♡ 6 2
◊ K 9 8 7 5 3
♣ A K Q 10 7

West leads the ♠K against South's contract of 6 Clubs.

P–91. The Black Forest

Susan and Tom were tracking in the Black Forest, the highland in south-west Germany, when they discovered a young man hanging from a tree. Their first impulse was to cut him down, but as he was obviously dead they decided to report the find to the police.

On examination it was found that the man had died about three days before he was discovered, and that it was neither suicide nor murder.

What do you think had happened?

B–91. Solution

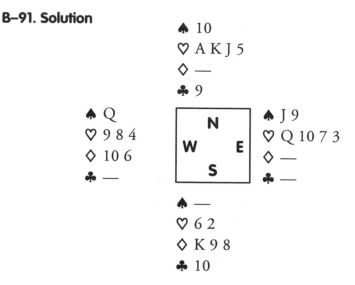

```
              ♠ 10
              ♡ A K J 5
              ◊ —
              ♣ 9

♠ Q                          ♠ J 9
♡ 9 8 4         N            ♡ Q 10 7 3
◊ 10 6      W       E        ◊ —
♣ —             S            ♣ —

              ♠ —
              ♡ 6 2
              ◊ K 9 8
              ♣ 10
```

West led ♠K, dummy's ♠A winning. South discarded a Diamond and cleared trumps. Then a small Diamond went to East's ◊A, and South ruffed the Spade return. A Diamond to dummy's ◊J showed that West held the guarded ◊10. The position was as shown above.

Here South could do no better than ruff ♠10, cash ◊K and finesse ♡J. **Down one**.

South could have increased his chances by crossing to dummy in Hearts before he leads the second Diamond. Now that East shows out on ◊J, South will easily take the rest by covering with ◊K and pressing out West's ◊10.

P–91. Solution

The man was a fighter pilot in the German air force. His plane had developed engine trouble and he had to bail out. His parachute got tangled up in the tree in such a way that the pilot was unable to free himself and after a few days he had died of exposure.

B–92.

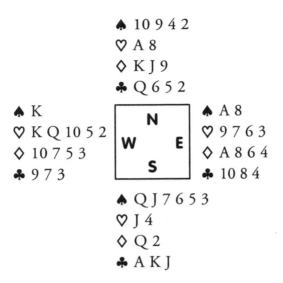

♠ 10 9 4 2
♡ A 8
◊ K J 9
♣ Q 6 5 2

♠ K
♡ K Q 10 5 2
◊ 10 7 5 3
♣ 9 7 3

♠ A 8
♡ 9 7 6 3
◊ A 8 6 4
♣ 10 8 4

♠ Q J 7 6 5 3
♡ J 4
◊ Q 2
♣ A K J

South's contract is 4 Spades. West leads the ♡K.

P–92. Boat in the bath

Rupert is sailing a plastic boat in his bathtup. The boat is loaded with nuts, bolts and washers. If Rupert dumps all these items into the water, allowing his boat to float empty, will the water level in the bath rise or fall?

B–92. Solution

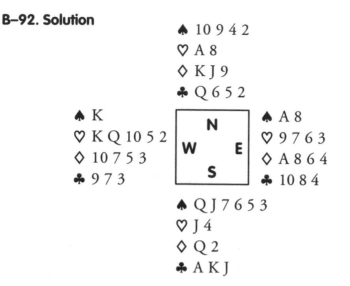

♠ 10 9 4 2
♡ A 8
◇ K J 9
♣ Q 6 5 2

♠ K
♡ K Q 10 5 2
◇ 10 7 5 3
♣ 9 7 3

♠ A 8
♡ 9 7 6 3
◇ A 8 6 4
♣ 10 8 4

♠ Q J 7 6 5 3
♡ J 4
◇ Q 2
♣ A K J

West led ♡K, dummy's ♡A winning. South could see four top losers. He decided to enter the closed hand with a Club and lead ♠Q and exited with a Club. South eventually had to concede two more tricks for **down one**.

It was a rather childish plan South chose. In fact, South could have made four Spades under his own steam. Having won the Heart lead, South immediately plays three rounds of Clubs, ending in dummy. All is well so far. Now, the thirteenth Club follows and ♡J is discarded in the closed hand. East ruffs with ♠8 (best) and then it does not matter what the defence does. When on lead, South plays a trump felling the Ace and King with a single shot.

P–92. Solution

The nuts, bolts and washers in Rupert's boat displace an amount of water equal to their weight. When they sink to the bottom of the bath, they displace an amount of water equal to their volume. Since each item weighs considerably more than the same volume of water, the water level in the bath goes down after the cargo is dumped.

B–93.

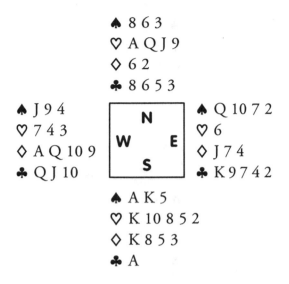

♠ 8 6 3
♡ A Q J 9
◊ 6 2
♣ 8 6 5 3

♠ J 9 4
♡ 7 4 3
◊ A Q 10 9
♣ Q J 10

♠ Q 10 7 2
♡ 6
◊ J 7 4
♣ K 9 7 4 2

♠ A K 5
♡ K 10 8 5 2
◊ K 8 5 3
♣ A

The Contract is 4 Hearts by South. West leads the ♣Q.

P-93. Word series

What is the next word in the following series?

aid, nature, world, estate, column, sense…

Is it (a) *water,* (b) *music,* (c) *welcome,* or (d) *heaven?*

B–93. Solution

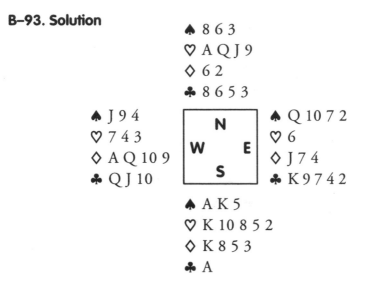

```
              ♠ 8 6 3
              ♡ A Q J 9
              ◇ 6 2
              ♣ 8 6 5 3
♠ J 9 4          N          ♠ Q 10 7 2
♡ 7 4 3      W       E      ♡ 6
◇ A Q 10 9       S          ◇ J 7 4
♣ Q J 10                    ♣ K 9 7 4 2
              ♠ A K 5
              ♡ K 10 8 5 2
              ◇ K 8 5 3
              ♣ A
```

West led ♣Q, South winning. A trump to dummy's ♡A was followed by a Diamond to the ◇K. West, however, won ◇A and played a second trump, East discarding a Club. A second round of Diamonds was won by West, who smartly led his last trump. South was now able to ruff a Diamond with dummy's last trump but at the end he had to concede a Spade and one more Diamond trick for **down one**.

South's play was reckless to say the least. He should have been grateful for not having got a trump lead from West. To make sure of at least 10 tricks, South should lead a low Diamond from the closed hand. Now the defence can lead trumps twice when in on Diamonds but the cannot prevent South from ruffing two Diamonds in dummy.

P-93. Solution

The answer is (d) *heaven*. The sequence of ordinal numbers is implied: first aid, second nature, Third World, Fourth Estate, Fifth Column, sixth sense, seventh heaven.

B–94.

♠ J 10 4
♥ K 7 2
♦ 8 7 5
♣ A 6 3 2

♠ Q 7 5 3 2
♥ Q J 8
♦ 4 3
♣ Q 10 8

♠ A 6
♥ 10 9 6 3
♦ K 9 6 2
♣ J 8 4

♠ K 9 8
♥ A 5 4
♦ A Q J 10
♣ K 7 5

South's contract is 3 no trumps. West leads the ♠3.

P–94. Fan power

You wanted to sail your model sailboat today, but there is no wind at all, and your boat is in the doldrums. Would it be possible to propel your boat by mounting a battery-operated fan on the rear of the boat and directing the fan to blow wind into the sails? Think before you answer.

B–94. Solution

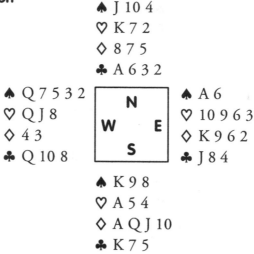

```
                    ♠ J 10 4
                    ♥ K 7 2
                    ◇ 8 7 5
                    ♣ A 6 3 2
♠ Q 7 5 3 2        ┌─────────┐      ♠ A 6
♥ Q J 8            │    N    │      ♥ 10 9 6 3
◇ 4 3              │ W     E │      ◇ K 9 6 2
♣ Q 10 8           │    S    │      ♣ J 8 4
                   └─────────┘
                    ♠ K 9 8
                    ♥ A 5 4
                    ◇ A Q J 10
                    ♣ K 7 5
```

West led ♠3, East's ♠A winning. The Spade return went to West's ♠Q, and South won the third round, East dropping a Heart. South had to get six tricks in the minor suits, so he crossed to dummy with a Club and finessed ◇Q. Next ♥K gave an entry for a second Diamond finesse, but ◇K didn't drop on the ◇A, and the contract was **down one**.

As so often happens, the declarer slipped at trick one. West was marked with ♠Q, and in order to create an extra entry to dummy, South should have jettisoned his ♠K on East's ♠A. By this move, South will be able to reach dummy for a third Diamond finesse over East, and that will give him nine tricks.

P–94. Solution

Strange as it seems, the fan will propel the boat—backwards! The reason is that not all of the wind generated by the fan is caught by the sail. The forward action is not enough to counter the backward reaction, so the boat is propelled backwards.

B–95.

♠ A K 6 3
♡ Q 5 2
◇ 8 6 4 2
♣ Q 10

♠ J 7 4
♡ 9 8 7 6 3
◇ Q J 10
♣ A 4

♠ Q 9 8 5
♡ —
◇ K 9 7 5 3
♣ 6 5 3 2

♠ 10 2
♡ A K J 10 4
◇ A
♣ K J 9 8 7

South plays 6 Hearts. West leads the ◇Q.

P–95. Can you?

'We eat what we can, and we can what we can't.'

Can you explain who could make this statement?

B–95. Solution

```
              ♠ A K 6 3
              ♡ Q 5
              ◊ 8 6
              ♣ —
  ♠ J 7 4                    ♠ Q 9 8 5
  ♡ 9 8 7 6                  ♡ —
  ◊ 10                       ◊ K 9
  ♣ —                        ♣ 6 5
              ♠ 10 2
              ♡ K J 10
              ◊ —
              ♣ K 9 8
```

West led ◊Q, South winning. ♡A disclosed the bad break, when East dropped a Diamond. Now a small Club was won in dummy, West winning the second round of Clubs. A Diamond lead forced South to ruff, and now the position was as shown above.

South had to shorten West's trump length, so he continued with his high Clubs. West, however, dropped all his Spades, and South could discard three of dummy's Spades. For the finish, however, West was able to ruff the first round of Spades for **down one**.

West made the best of it, but South should have made his contract with careful timing. Having won the third trick with ♣Q, he should have cashed ♠A before he continues Clubs. South will the be able to discard all dummy's remaining Spades on his high Clubs, and then making his slam contract with a Spade ruff in dummy.

P–95. Solution

This statement was made by a salmon fisherman who was asked what he did with all the fish he caught.

B–96.

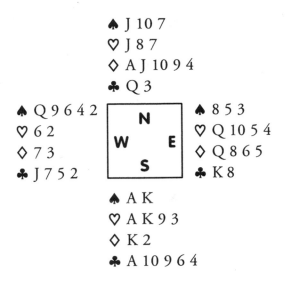

♠ J 10 7
♡ J 8 7
◇ A J 10 9 4
♣ Q 3

♠ Q 9 6 4 2
♡ 6 2
◇ 7 3
♣ J 7 5 2

♠ 8 5 3
♡ Q 10 5 4
◇ Q 8 6 5
♣ K 8

♠ A K
♡ A K 9 3
◇ K 2
♣ A 10 9 6 4

South's contract is 3 no trumps. West leads the ♠4.

P–96. The rifle

A man holds a rifle horizontally 6 feet above the ground. At the moment he fires it, another bullet is dropped from the same height, 6 feet. Ignoring frictional effects and the curvature of the Earth, which bullet hits the ground first?

B–96. Solution

```
            ♠ J 10
            ♡ J 8 7
            ◇ 10 9
            ♣ Q 3
♠ Q 9 6 2              ♠ 5 3
♡ 6                   ♡ Q 10 5 4
◇ —                   ◇ 8
♣ J 7 5 2             ♣ K 8
            ♠ —
            ♡ A K 9 3
            ◇ —
            ♣ A 10 9 6 4
```

West led ♠4, South winning. A small Club to the ♣Q went to East's ♣K, and the Spade return was taken by South's ♠A. Now South decided to combine his chances by laying down ♣A on the chance of dropping ♣J. Nothing happened, however, so South cashed ◇K and finessed ◇J. East won ◇Q and played his last Spade West then took three Spade tricks, and the contract went **down two**.

Here South missed the proper timing. Having won the opening lead, he should have cashed ◇K and ◇A, followed by ◇J. From the closed hand, South jettisons ♠A leaving the position shown above.

East is on lead and can do no better than return a Space to West's ♠Q, South discarding a Club. Now West's best lead is a Club to East's ♣8 and South's ♣9. A small Club goes to East's ♣K, and now East is forced to give dummy the lead, South making ten tricks.

P–96. Solution

Both bullets will hit the ground at the same time. Horizontal velocity does not affect downward acceleration.